THE FIRST WORLD WAR IN PHOTOGRAPHS

1918

JOHN CHRISTOPHER & CAMPBELL McCUTCHEON

AMBERLEY

First published 2015

Amberley Publishing
The Hill, Stroud
Gloucestershire, GL5 4EP

www.amberley-books.com

British Library Cataloguing in Publication Data.
A catalogue record for this book is available from the British Library.

ISBN 978 1 4456 2212 5 (print)
ISBN 978 1 4456 2228 6 (ebook)

Typeset in 11pt on 15pt Sabon.
Typesetting and Origination by Amberley Publishing.
Printed in the UK.

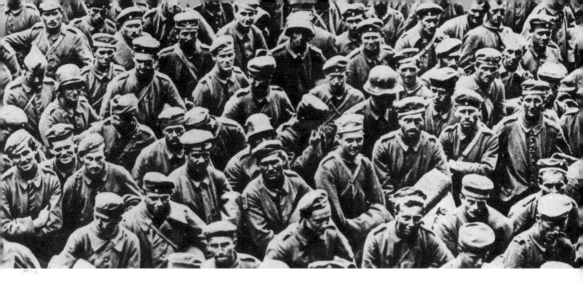

Contents

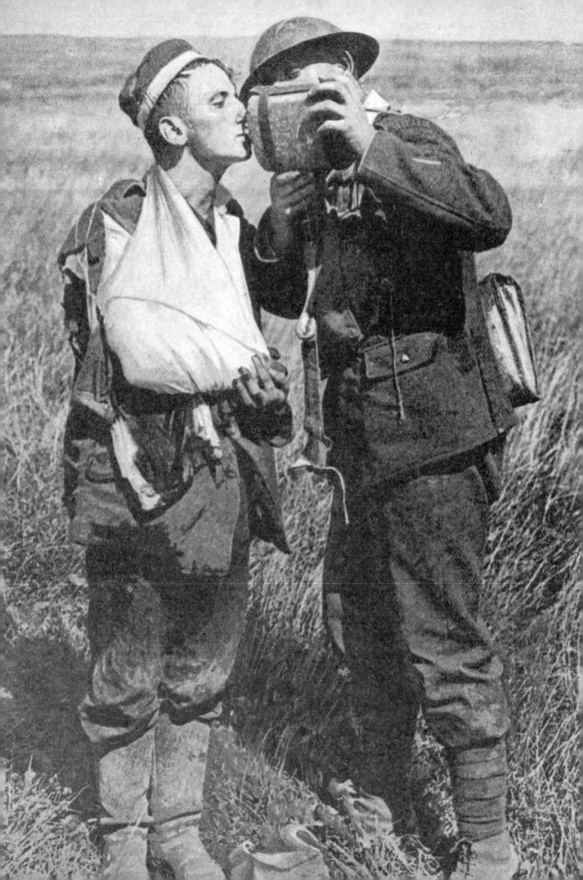

Introduction: The Guns Cease to Fire

1918 is the last year of the war and the combatants know it. Hundreds of thousands of Americans are arriving every month and they will have a profound effect on the outcome. With the imminent arrival of these hundreds of thousands of American troops, the German High Command decide to make a great push and plan an offensive on the Western Front.

Finland gets its independence on 1 January. Bolshevik Russia cuts free its former colony and recognises the previous month's declaration of independence of the country. America's president, Woodrow Wilson, gives a speech to Congress on 8 January stating his fourteen-point peace program. This is designed to prevent future wars and it proposes an international body that will settle disputes between countries. On 20 January, the *Breslau* and *Goeben*, which have been under Turkish control since 1914, make a sortie into the Aegean to draw Allied attention away from Palestine and the conflict there. Both ships sail into an Allied minefield with the *Breslau* being lost. The *Goeben* is forced aground but does not sink. Allied air attacks are made on the *Goeben* in the hope she will be damaged or sunk but the Turks manage to rescue her. She is refloated and towed to safety. *Goeben* survived in the Turkish navy until the 1970s and was broken up between 1973 and 1976.

In Mesopotamia, on 27 January, a British force is sent from Baghdad to Baku, the home of the major Russian oilfields. They are being eyed by both Germany and Turkey and Britain invades before the Central Powers can act. It takes till August to reach the oilfields in Baku. Estonia, which has also declared independence from Russia, asks for German help on 28 January to attack the Bolsheviks who are trying to overturn the independence movement. By 25 February, the Germans and Estonians have pushed the Bolsheviks out of Revel. In Finland, the 'Red Guard', a Social Democrat militia, stage a coup and proclaim a socialist workers' republic in Finland. The Finns call on help from the Germans to help them against the Red Guard.

The beginning of February brings a mutiny at Cattaro, the main Austro-Hungarian naval base on the Dalmatian coast. February also sees the

Opposite page: A kindly Tommy gives a prisoner a drink from his water bottle. Such images were the bread and butter of the Allied propagandists in the last year of the war. 'The battle over, this Scots Guardsman forgets at once the bitterness of strife. His gesture illustrates how little enmity there was between the opposing forces.'

Germans lose patience with the Bolsheviks and attack them once more, reaching into the Ukraine and toward Petrograd. Since December 1917, the Germans had been discussing peace terms with the Bolsheviks at Brest-Litovsk. The Germans have become fed up with the Bolsheviks and want to use the attack to force an agreement for peace so they can transfer troops to the Western Front, where they are so badly needed to counter the influx of Americans troops. The Bolsheviks cannot contain the advance as they have neither troops nor material to fight with.

On 24 February 1918, the German commerce raider SMS *Wolf* returns to Kiel after an epic voyage of 451 days that saw her sink fourteen ships, with minefields laid by her claiming another thirteen. She had made the single longest unaided voyage of the war, been at sea on a single voyage for longer than any other ship afloat and had masterfully been sailed back to Germany with 467 prisoners of war and copious quantities of rubber, copper, zinc, brass, even silk and many other items essential to the war effort. Captain Nerger was awarded Germany's highest order, the Pour le Mérite, for his long voyage and the ship was greeted by thousands on her return to port. The Turks take advantage of the collapse of the Russian army after the Bolshevik revolution and they attack Armenian areas occupied by the Russians on 24 February. Their ultimate goal is not Armenia but the Russian oilfields in neighbouring Baku, Azerbaijan.

On 3 March, the Bolsheviks are forced to agree peace terms at Brest-Litovsk. They have to give up control of Finland, Estonia, Latvia and Lithuania, as well as the Caucasus, Poland and 'White' Russia, the parts of Russia not held by the Bolsheviks. The Ukraine and its grain belt are held by the Germans, who desperately need the wheat to prevent starvation in Germany. The Germans have planned a 'knock-out' offensive in the West, now that their eastern border is secure. The German general, Erich Ludendorff, has transferred seventy divisions from the Eastern Front, and this gives Germany a huge numerical advantage over the British and French. The plan is for an attack between the British and French armies and to use this to the advantage of the Germans. The hope is that the French will retreat and attempt to protect Paris and the British will try to save the Channel ports, causing a divisive split between the armies that can be exploited. His three armies are to advance along a 50-mile front from St Quentin and La Fére to Arras. There are sixty-three divisions for the attack, facing just twenty-six British divisions. Operation Michael, as the offensive is codenamed, is also to become known as the Kaiserschlacht, or Kaiser's Battle. The battle begins with 6,000 guns making a five-hour bombardment of the British forces using high explosive and gas shells. As the bombardment ends, German stormtroopers attack through fog towards the British troops. Soon, the British are in retreat. The Fifth Army collapses and the Third Army's flank is exposed. The Third Army withdraws over the Somme. Two days later, on 23 March, the Germans begin bombardments of Paris with long-range eight-inch guns. They can hit Paris from fifty miles away. The guns do not cease until 9 August, by which time 367 shells have been fired, 256 Parisians killed and another 620 are wounded. They cease only because the Germans have been forced to withdraw in August, out of range of Paris. The Germans break through between

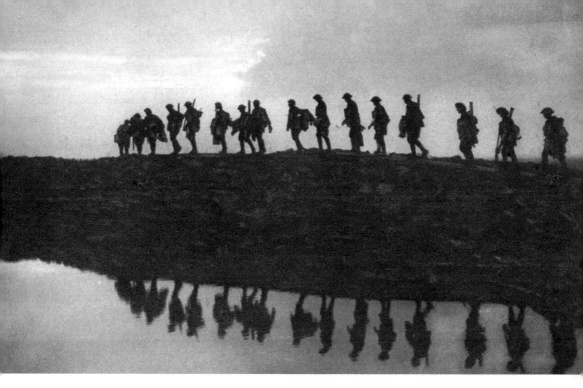

Above: After a battle, a column of Allied troops silhouetted against the sky as they move up to relieve the front trenches. You can almost hear them singing 'It's a long way to Tipperary...'

the Third and Fifth Armies on 25 March. The Second Army, under General von der Marwitz, is ordered to head for Amiens and the Eighteenth Army is sent towards Paris. The Seventeenth Army is sent towards the Channel ports. Haig, Britain's commander-in-chief, rushes troops to stop the Germans pouring through the gap between the two armies but Pétain, the French commander, as the Germans suspected, holds his troops back to defend Paris.

From 26 March 1918, General Foch takes control of the Allied troops facing the Germans in an attempt to co-ordinate the forces of Britain, France and America. He sends thousands of French troops to plug the gap that has opened up between the Germans and Allies. General Byng's Third Army manages to stop the advancing Germans on the 26th. Two days later, the Germans attack again north of the Somme but their advance is halted and operations north of the Somme cease while all efforts are made in the south, where the Germans have captured Montdidier on 27 March. They have moved the front some forty miles in six days and are close to Amiens but are also exhausted and are facing fresh British and French troops. Within ten miles of Amiens, at Villers-Bretonneux, the German advance falters and is halted. Edward Rickenbacker, the future American fighter ace, scores his first kill on the Western Front. He will end his short war with twenty-six kills.

On 1 April, Britain's Royal Naval Air Service and Royal Flying Corps are amalgamated and become the Royal Air Force. The Finns have called for aid from Germany and the German Baltic Division arrives on 3 April to fight against the pro-Bolshevik militia. The German army in France concedes defeat in its advance's

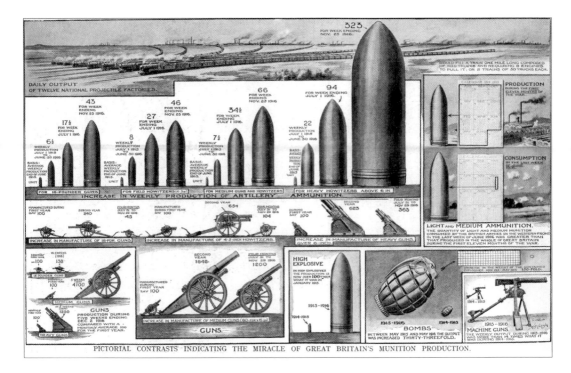

Two images demonstrating the staggering statistics of the war in terms of munitions production and manpower. *Above:* Published in *The Great War*, 1918. 'The rapid growth in the output of guns and explosives that followed the shell scandal revelations of *The Times* in May 1915. During the last week of 1916, the British armies on the Western Front used up a greater quantity of light and medium munitions than had been been produced in the first eleven months of the war.' *Below:* 1918 poster for a display of war relics held in the USA.

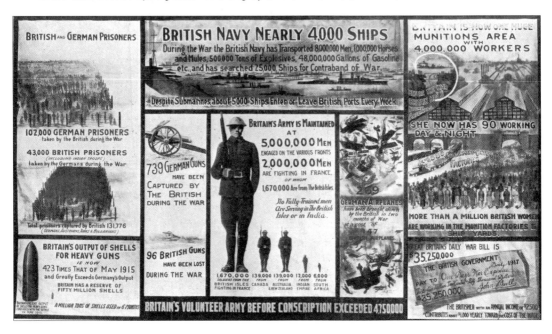

objectives and calls off the offensive on 5 April. It is obvious that Amiens will not be reached but the German armies have advanced forty miles. The fight has cost half a million British, French and German casualties. The Germans move their advance on 6 April to the front held by the British First and Second Armies. General Ludendorff's plan here is to attack on a narrow front that will take the Germans towards the Channel ports through which the British receive their supplies and reinforcements. The attack is preceded by a three-day artillery bombardment and the advance begins on the 9th. The Sixth Army moves on a twelve-mile front towards the British, advancing from Neuve-Chapelle. There are two divisions of Portuguese troops facing the Germans and they are soon cast aside and forced back five miles. The next day, four German divisions attack the British Second Army and it retreats past Messines and Wytschaete. By 12 April, the gap is 30 miles wide and the Germans are closing in on Hazebrouck, to the south-west of Ypres. Douglas Haig orders the British not to retreat further. General Ferdinand Foch is appointed commander-in-chief of the Allies on the Western Front on 14 April. The German advance is halted along the River Lys on 17 April. Newly arrived French troops, as well as British soldiers, have helped stop the Germans. The Germans do not give up and continue to attack, but by the end of the month it is obvious the attacks have failed. 100,000 on each side have become casualties. Baron Manfred von Richthofen, the German ace, dies during a dogfight over the Western Front. He has shot down eighty Allied aircraft and is replaced by Hermann Göring.

There are no major naval actions in the early part of the year but the German submarines, destroyers and torpedo boats operating out of Zeebrugge and Ostend are a thorn in the side of the Allies. Masterminded by Vice Admiral Sir Roger Keyes, a plan is made to attack both ports and sink old, redundant warships across the entrances, blocking them from use. An attempt is planned for 2 April but the weather is wrong and a smokescreen cannot be laid. On 23 April, some seventy warships and thousands of Marines head from Dover for Zeebrugge and Ostend. Packed with men of the Royal Naval Division, *Vindictive* heads for the sea walls at Zeebrugge. Her troops land and occupy the Germans while a submarine full of explosive is blown up alongside the sea wall. While the Marines are fighting the Germans, three blockships, HMS *Thetis, Intrepid* and *Iphigenia,* are sailed into the inner harbour. The plan is that they should block the canal but *Thetis* runs aground at the entrance to the inner harbour. Both *Intrepid* and *Iphigenia* reach their destination but are sunk at the wrong angle. The attack on Ostend is even less successful, with the blockship HMS *Brilliant* running aground on mud and *Sirius* crashing into her port side. German submarines can still get in and out of both harbours at high tide. Eight Victoria Crosses are awarded for the actions but in no way are they a success. The Germans lose thirty-four dead but the British casualty list runs into the hundreds, with some 227 dead and over 300 wounded. In Finland, the end of the month sees the Finnish 'White Guards' score a major victory over the pro-Bolshevik 'Red Guard' at Viborg on 28–29 April.

On 7 May, Romania surrenders, signing the Treaty of Bucharest. The Romanians had signed an armistice in December 1917 with the Axis powers, having lost

400,000 troops and over 80 per cent of Romanian territory. The Romanian king has not signed the surrender documents and this oversight helps the Romanians claim compensation at the war's end. A second attack is made on Ostend on 10 May, using HMS *Vindictive* as the blockship. She had been heavily damaged after the first raid on Zeebrugge and was already redundant. Filled with concrete and explosives, she is sailed into the port and scuttled. She is raised in 1920 and her bow is now a memorial at Ostend to the two raids. Three Victoria Crosses are awarded to men on this second raid. HMS *Phoenix* is torpedoed in the Adriatic on 14 May.

French American ace Raoul Lufbery is killed on 19 May. He has fought with the French and has thirty-eight victories with them and another seventeen with the USA after it enters the war. The Germans open their third major offensive of the year on 27 May. This attack, against the French forces at Chemin des Dames on the Aisne, is nothing more than a diversion to pin down troops while the British in the north are attacked again. Forty-four divisions attack twelve French and British divisions. By midnight, the Germans have advanced ten miles and captured the Chemin des Dames as well as numerous bridges over the Aisne. The attack has

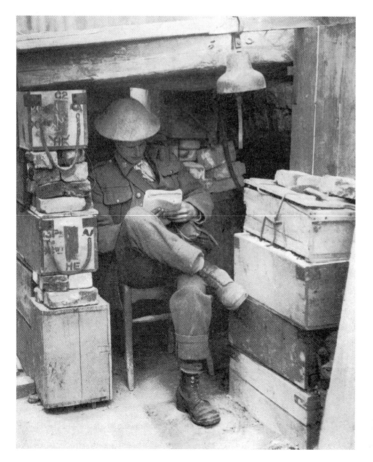

In a war that introduced the world to new forms of industrialised slaughter one of the greatest horrors inflicted on the men at the front was the use of poisonous gas by both sides. Shown left, a Canadian gas sentry passes the time in a shelter made from old ammunition boxes in the spring of 1918. His job is to ring the bell when gas shells come over.

been preceded by a bombardment using 4,600 guns and has been so successful that the German High Command want to proceed towards Paris, some eighty miles away. The French are bolstered by American troops of the 2nd and 3rd Divisions, who go into action on 30 May against the Germans, who are already close to the River Marne. On 28 May, the American 1st Division goes to war. It is the first time the Americans are in action in France. The action takes place mainly on the Somme, around the village of Cantigny, which is to the east of Montdidier, and the Americans soon capture Cantigny, taking 200 prisoners. They repulse numerous German counterattacks over the next few days, taking 1,600 casualties, among them 199 dead.

At Chateau-Thierry, on the Marne, the US 3rd Division goes into action on 2 June. The 3rd prevents the German stormtroopers crossing the Marne. Counterattacking between the 2nd and the 4th, they force the Germans back across the Marne. The German offensives are called off on 4 June. An advance of twenty miles over a thirty-mile front has been made. The Germans are exhausted and their supply chain is at full stretch. They have lost 125,000 men, with a similar number lost on the Allied side too. The Allies have not stopped though, and on 6 June, the Americans attack at Belleau Wood, near Chateau-Thierry. The American 2nd Division is facing four German divisions but, after three weeks, Belleau Wood is cleared for the loss of 1,800 Americans killed and 7,000 wounded.

The Austro-Hungarian navy attempts to smash the Otranto blockade of the Adriatic on 9 June and the dreadnought *Szent Istvan* is sunk by Italian motor torpedo boats. The Germans launch their fourth offensive of the year on 9 June as they continue to put pressure on the Allies. The aim is to join up the two salients forced through in previous offensives. The French are forewarned by German deserters and are prepared and order an artillery barrage on the Germans, which drops on their assault troops. Despite the barrage, the Germans advance five miles on the 9th. The Germans attack near Soissons on 10 June but the two armies fail to meet up. Three French and two American divisions counterattack on 12 June, with the German advance halted on the 13th. The Americans and French lose 35,000 men, with German casualties much higher. The Germans are becoming more desperate and a fifth offensive is planned. In Austria-Hungary, the Austrians launch an attack from the Tonale Pass on the same day. It is merely a diversion from the real attack, which will begin on 15 June at the Piave river. The Austro-Hungarians are fighting alone as the Germans have withdrawn their troops to the Western Front but they commit fifty-eight divisions to an attack that should sweep over much of northern Italy. The attacks fail, and on 17 June the advance to Verona is halted by the Italians, who quickly organize a counterattack. The Austro-Hungarians suffer 40,000 casualties and are forced to retreat. The attack across the Piave river is on a wide front and the Austro-Hungarian Fifth and Sixth Armies soon capture three miles over a fifteen-mile wide front. Soon they are up against the defences of the Italian Third and Eighth Armies. The Austrians make gains but they are counterattacked on 18 June and retreat. The Italians make concerted aerial attacks on the Austro-Hungarians, and this, plus worsening weather, stops supplies getting

to the front. By 22 June, the Austro-Hungarians are defeated and are forced back across the Piave. 150,000 casualties include 24,000 captured. They are near defeat but the Italians decide to wait and prepare for an offensive later in the year.

French and British warships sail to Murmansk and occupy the port on 23 June in an attempt to halt Japanese expansion in the area. Archangel and Vladivostock will both be occupied in August. The Allies support the White Russians fighting the Bolsheviks and help repatriate the Czech Legion, who are fighting the Bolsheviks too. The Czech Legion is a 100,000-strong group of Austro-Hungarian prisoners who are now fighting their way out of Russia in the confusion of the Revolution. The Americans send two divisions to Vladivostock too but their instructions are only to prevent Japanese expansion in the area and not to become involved in internal Russian politics. One of Britain's best aces, James McCuddden, crashes on take-off on 9 July and is killed. In Lithuania, German Prince Wilhelm is named as King Mindove II. The Russian province has been occupied by the Germans since 1915. On 15 July, the fifth great German offensive on the Western Front takes place, this time in Champagne, along the Marne. This is intended to take troops away from northern France and the Channel ports so that they can be attacked. Three German armies, the Seventh (which strikes across the Marne), the First (advancing towards and around Rheims) and the Third (to attack Châlons-sur-Marne), face the Allies. The French know of the attack as they have noticed the build-up and they bombard the Germans. The German Third Army is halted by the French First Army on the 15th and German efforts are concentrated to the west of Rheims. The German Seventh Army reaches the Marne between Épernay and Chateau-Thierry. French, British and American soldiers force them back and by the 17th the offensive is halted. Since March, the five offensives have caused half a million German casualties. They cannot be replaced and the Allies are gaining strength at the rate of a third of a million American troops each and every month. The Germans pragmatically plan to withdraw and shorten their new front line but the Allies have plans for an offensive.

In Russia, the Czar and most of his family are killed by the Bolsheviks at Ekaterinburg, Siberia, during the night of 16–17 July. They have been exiled since the winter of 1917. Despite rumours that one of the children has survived, DNA tests on the bodies, which are discovered many years later, prove all of the children and the Czar and Czarina died that night.

The Allied counter-offensive on the Marne begins on 18 July. The attack takes place between Soissons and Rheims, and the battle is known now as the Second Battle of the Marne. The French attack with three armies, supported by US troops. Three attacks are made simultaneously and the Germans are forced back as their armies collapse under the weight of the onslaught. The troopship *Justicia* is hit by torpedoes on 19 July and, after other attacks, sinks the following day.

On 20 July, General Ludendorff calls off a proposed attack in northern France due to the worsening state of the front in the Marne. On 26 July, the Czech Legion captures Ekaterinburg. They have been trying to evacuate themselves from Russia but have been thwarted by the Bolsheviks and are now fighting their way out,

using weapons captured from the Russians. Britain's top fighter ace is killed after being shot down by German anti-aircraft fire. He has shot down seventy-three German aircraft before he too is killed on 26 July.

By August, after their series of failed offensives, the German soldiers are low on equipment and morale. The sea blockade of Germany has strangled the country and it is running out of food, equipment and war supplies. 300,000 American troops are now arriving monthly in the ports of France and soon will outnumber the German and Austro-Hungarian forces. On 2 August, the Germans begin a withdrawal from Soissons as they are forced back by French and American troops. By the 6th, they have retreated to a line from the Aisne and Vesle rivers and have lost most of the ground captured between Soissons and Rheims. The Germans have lost many tens of thousands of their best troops and have no new replacements. On 8 August, the British Expeditionary Force begins the Amiens Offensive. The plan is to clear the railway line of Germans and reopen it between Amiens and Paris. On a fifteen-mile front, around 400 tanks attack after a short bombardment. Eleven divisions follow the tanks into battle. The Germans flee from the battlefield and the British and French forces push forward around ten miles. 15,000 Germans surrender as soon as they meet the Anglo-French force. By 10 August, the Allies attack the south of the Amiens salient and the Germans abandon Montdidier, allowing the railway to reopen. The offensive stops on 12 August, with mounting German resistance halting the Allied troops. The Germans lose 40,000 dead or injured and 33,000 taken prisoner, with the Allies losing 46,000 troops killed or injured. The second phase of the battle begins on 21 August. The Germans pull back as they simply cannot muster any more men to fight. Their reserves are all but gone and yet the Allies still push on. They have retaken the Lys and Amiens salient. On 30 August, the American First Army takes up positions around the St Mihiel salient in preparation for a huge attack in September.

The war is going disastrously on all fronts for the enemy forces and by 2 September the Germans begin withdrawing back to the Hindenburg Line from where they started in March. Between 3 and 10 September, the withdrawal is completed, despite constant attack by British, American and French forces. The British have to stop their attack, having run out of reserves. British and French losses are 42,000 with the Germans losing over 100,000, with 30,000 captured. General Ludendorff has come to the stark realisation that the war is lost. He withdraws his troops from the St Mihiel salient near Verdun on 8 September in advance of the attack he fully expects to take place here soon. The attack comes on 12 September, when the US 1st Army and the French II Colonial Corps attack. The St Mihiel salient has been held by the Germans since 1914. Around 600 aircraft support the attack, which succeeds well on its first day when the Germans collapse. By 16 September, the majority of the salient has been captured. The attack halts as the Americans pull some of their troops out of St Mihiel in preparation for a new offensive in the Meuse-Argonne area.

The Turks have reached Baku, capturing the city and its oil fields on 14 September, forcing the British, who have held the area for some time, to withdraw.

In the Balkans, the French commander of the Allied force in the area launches an attack on the Bulgarians. The Battle of the Vardar River sees the Bulgarian army split in two and Skopje falling on 29 September. The onslaught sees the Bulgarian army begin to collapse. Meanwhile, in Palestine, Brigadier General Allenby orders the beginning of the Battle of Megiddo. The Turks hold a line between Jaffa and the Jordan river, with three armies facing the British. The 40,000 Turkish troops are low on supplies thanks to the efforts of T. E. Lawrence and the Bedouin of the Arab Revolt, who have attacked the Hejaz Railway continuously. Allenby commands 69,000 troops and he intends to attack along the coast but has led the Turks to believe he is attacking close to the Jordan and has built dummy supply camps to fool the enemy. Allenby's main force of 35,000 men, with 350 guns, attacks at 0430 on 19 September. They face around 8,000 Turks and 130 guns along the coast. The plan is to attack and then swing inland, trapping the Turkish Seventh and Eighth Armies as they retreat. The Turkish lines are soon broken and, with the British aircraft destroying their communications and railways, the Turks cannot bring up reinforcements or supplies. The Seventh Army is pretty much destroyed and the Eighth tries to escape. Around 25,000 Turkish troops are captured and the Turkish Fourth Army retreats to Damascus. The Turkish forces in Palestine and Syria are effectively destroyed and Allenby can race for Damascus.

The final few days of September 1918 see the American 1st Army launch the Meuse-Argonne offensive, north of Verdun, on the 26th. The 1st Army is composed of almost one million men. The plan is to force the Germans from the Hindenburg Line and make them surrender. At 0525 the battle begins and the US forces make an advance of ten miles in the first five days of the attack. By 3 October the Americans and French have taken two of three defensive lines in the Hindenburg Line. Another offensive in the north sees the British attack towards Cambrai and St Quentin. On 27 September, the first day of the offensive, the British smash the German lines, advancing to within three miles of Cambrai on that first day. By 30 September, the Third Army begin to occupy the suburbs of Cambrai. The Belgians attack too, on 28 September, around Ypres, where the Germans are swiftly dispatched. They begin to advance along the coast, despite the waterlogged conditions. British, French and American reserves join the fray on 29 September and the Hindenburg Line is abandoned by 4 October. The Germans retreat to a hastily prepared defensive line along the banks of the River Selle, which is about ten miles behind the Hindenburg Line. The first of the Central Powers to surrender is Bulgaria, which capitulates and signs an armistice on 30 September, having seen the collapse of their armies.

Damascus is captured on 1 October, after the rout of the Turks in this part of the Middle East. Some 20,000 Turks surrender to the British. Beirut is captured on 2 October and Aleppo on 25 October. On 5 October Beirut is occupied by French naval forces. 6 October sees the German chancellor ask Woodrow Wilson for an armistice. In Turkey, the government falls on 14 October and Ahmed Izzet Pasha asks for an armistice. On the same day, the US-French offensive on the Meuse-Argonne enters its second phase. The Americans have been reorganised and the

two armies quickly reach the enemy's third lines of defence. Despite stiff fighting, the sheer weight of numbers sees the Allies advance forward by the end of the month. The Germans have had to take reinforcements from the other beleaguered battlefields on the front. At the Selle river, from 17 October, the Allies push through the German lines, capturing 20,000 prisoners. On a twenty-mile front, the Germans are pushed beyond the Scheldt river by 31 October. The Belgians attack around Ypres too to keep pressure on the Germans. In Italy, on 23 October, an Italian offensive starts along the Piave. Fifty-seven Italian, British and French divisions face fifty-two Austro-Hungarian divisions. The Austro-Hungarians have almost given up the fight though. Morale is low and fighting spirit even lower. They do, however, manage to block an advance at Mount Grappa, but at Vittorio Veneto, despite initial successes, the Austro-Hungarians fail to prevent British and French bridgeheads on their side of the Piave. By 28 October, both bridgeheads are secure and the Austro-Hungarians are in disarray.

The British, sensing an imminent Turkish defeat, head for the oil fields of Mosul, Iraq. After a two-day battle on 28–29 October, the British forces capture 11,300 Turkish soldiers and fifty-one guns when the Turkish leader, General Ismael Hakki, surrenders. General Ludendorff is replaced on 26 October by General Wilhelm Groener after Ludendorff argues with Field Marshal von Hindenburg and states the war is lost. German sailors mutiny at Kiel on 29 October after Admiral Hipper suggests a do-or-die attack on the British navy. 40,000 mutiny and the revolt spreads. The sailors capture Kiel on 4 November. It is the start of a series of uprisings across Germany. On 30 October, the Turks meet the Allies at Mudros, the Greek island that has served as a base for the Allies, to discuss an armistice. Under its terms, the Turks must withdraw from the Trans-Caucasus region and Constantinople is to be occupied and controlled by the various Allied powers. The Turkish war is over! The end of the month sees a disintegration of the Austro-Hungarian forces on the Piave. Vittorio-Veneto is captured, splitting the Austrian forces in Italy. A week of fighting has seen a fifteen-mile incursion along a thirty-five-mile front. The Tagliamento river is reached on 2 November and, in the Trentino region, British and French forces are advancing rapidly. On 3 November, the battle is over. The Austro-Hungarians have lost 300,000 troops for 38,000 casualties on the Allied side. Austro-Hungary's flagship *Viribus Unitis* is sunk during an Italian attack in the Adriatic on 1 November. Two days later, the Allies capture the port of Trieste and Austria-Hungary sues for peace. Only Germany remains in the fight.

On 1 November, the war is almost over but on the Western Front, the Meuse-Argonne offensive continues. The Americans capture Buzancy, allowing the French to advance over the Aisne in force. Sedan falls on 6 November. HMS *Campania*, the seaplane carrier, drags anchor on the morning of 5 November when off Burntisland. She collides with HMS *Royal Oak* and then HMS *Glorious*. Settling by the stern, the ship begins to sink. By late afternoon, she has gone to the bottom, taking eleven aircraft with her. Unrest is rising at home for the Germans as their leaders realise the war is over. The people have no fight left, food is running low and there are riots across Germany. They sue for peace and armistice talks

begin at Compiégne. On 7–11 November, the terms of an armistice are thrashed out in a railway carriage in a remote siding. For the Germany army it is the end, despite fighting continuing along the Front. The Meuse-Argonne offensive has been terminal for the Germans. For the Americans, it has had a high cost too. They have lost 117,000 casualties since September. For the German navy, it is defeat too. All of their submarines must be surrendered and the surface ships are ordered to Allied ports to be interned. The next day, Allied warships sail through the Dardanelles and anchor at Constantinople. A series of events has led to the final armistice signing. Fighting continues and Mons and Ghent are close to capture as the war ends. On 9 November, the Kaiser abdicates and a republic is created in Germany. Both right and left-wing factions vie for control. In Austria, on 11 November, the Emperor abdicates. At 1100, the guns cease to fire. An armistice, agreed only four hours previous, comes into force and the war is over. The Germans must surrender land they have taken, guns, stores, ammunition and their naval fleet. The Poles eject the Germans from their country too on 11 November and the new Turkish government falls. Chaos reigns in the former Central Powers. On 12 November, two new countries are created when the Austro-Hungarian empire becomes Austria and Hungary. Czechoslovakia is created on 14 November and German troops leave the Ukraine on 15 November. A British naval force takes Baku from the Turks on 17 November. In other parts of Russia, Admiral Kolchak seizes power at Omsk.

The major event of the end of the sea war is the surrender of the German fleet on 21 November. Admiral David Beatty, on HMS *Queen Elizabeth*, takes the surrender. Almost 250 Allied ships await the eighty or so German vessels, and they are escorted into the Firth of Forth and then over the coming days sent to Scapa Flow, after checks that they carry no ammunition. King George V views the German battleships, cruisers and destroyers soon after. The submarines begin to appear in Allied ports too, with many interned at Harwich. For them, the war truly is over. War continues in revolt-stricken Russia, where Bolsheviks clash with forces opposed to them. In Northern Rhodesia, the Germans surrender on 26 November. The 175 Germans and 3,000 native troops have held down a force of around 130,000 in their guerilla campaign. Montenegro announces it will merge with Serbia on 26 November.

On 1 December, Allied forces occupy the Rhineland. On 13 December, Woodrow Wilson becomes the first American president to leave the country and he arrives in France. He will visit Italy and the United Kingdom too and is instrumental in arranging the final peace treaties according to his fourteen-point plan. On 18 December, French troops occupy Odessa to ensure weapons and supplies can be sent to Ukrainians fighting the Bolsheviks. With the continued occupation of Vladivostok and the fighting in Murmansk and Archangel, the war would continue into 1919.

The German fleet is lined up at Scapa Flow and its fate is awaited – the final reckoning will be in June 1919, once the Armistice has turned into full-blown peace. After five years of bitter fighting the war is finally over.

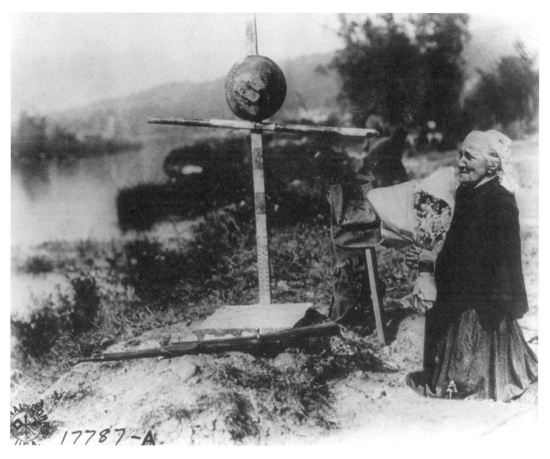

Above: In the spring of 1918 a French peasant woman lays flowers at the grave of her son who had been killed in the fighting.

A high price

But at what cost was this terrible war over? The numbers individually are staggering when one looks at them on a yearly basis but are truly horrendous when viewed over the whole war. Sixty-five million men were mobilised to fight in the war. Of those sixty-five million, eight million were killed and twenty-one million wounded.

In Germany, eleven million were mobilised, of which 1.8 million were killed. In Austria-Hungary, the figures were 7.8 million and 922,000. Turkey conscripted 2.8 million, of whom 325,000 died. In Bulgaria, 1.2 million were mobilised and 76,000 died. Around 3.1 million of the prime of their nations were killed.

The Allies fared much worse! France mobilised 8.4 million, of whom 1.36 million died. The British Empire raised 8.9 million soldiers, of whom 908,000 were killed. Russia raised 12 million, with 1.7 million killed. Italy mobilized 5.6 million, of whom 462,000 were killed. The US had 4.3 million combatants, of whom 50,000

were killed. Belgium's army had 267,000 men, of whom 14,000 were killed. In the smaller counties soldiers mobilised and killed included 707,000 and 45,000 in Serbia, 50,000 and 3,000 in Montenegro, 750,000 and 335,000 in Romania, 230,000 and 5,000 in Greece, 100,000 and 7,000 in Portugal and 800,000 and 300 in Japan.

Civilian casualties included 6.1 million, of which over 4 million were in Russia and Turkey, although much of Turkey's deaths were in the Armenian communities in which the Turks tried to commit genocide.

Ultimately, the war achieved nothing apart from setting the scene for the even bigger conflict that would occur in 1939. The peace treaties effectively bankrupted the Central Powers, leaving them little opportunity to grow and prosper, and led to the nationalist movements taking power in Germany. It also took the cream of a population from every combatant nation, with a change in demographic as a result. The effects on those injured or traumatised by the war was, and still is, incalculable. Whatever, it achieved little, apart from creating a fractured Europe that would end in war within a generation. The peace treaty that was reached in 1919 was an example of a punishment too far. The Central Powers had to pay huge war reparations, regardless of their ability to do so. The peace settlement in the Middle East created a legacy that continues to haunt us today, despite the opportunity to stablise the region at the time, and, despite the Armistice, war continued in numerous parts of the world.

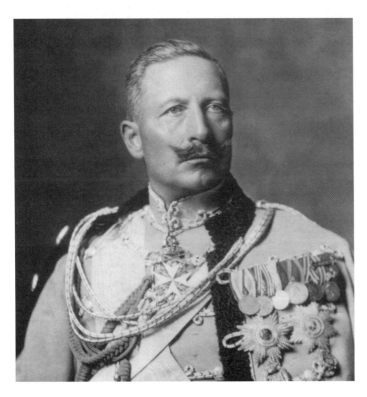

Kaiser Wilhelm II, left, abdicated on 9 November 1918, following the uprisings in Berlin. Germany was declared a republic later that same day. Wilhelm went into exile in the Netherlands, which had remained neutral during the war, and avoided calls for his extradition and trial. He died on 3 June 1941, aged eighty-two, and having vowed to never return to his homeland until the restoration of the monarchy he was buried in a mausoleum in the grounds of his Dutch home, Huis Doorn.

JANUARY 1918

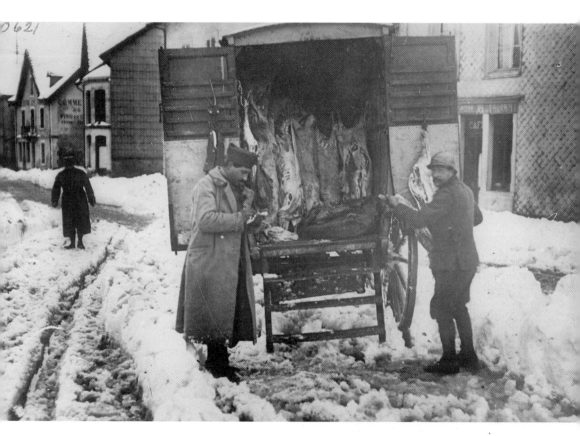

Above: French personnel loading meat on a wagon to feed the men at the front, 1918.

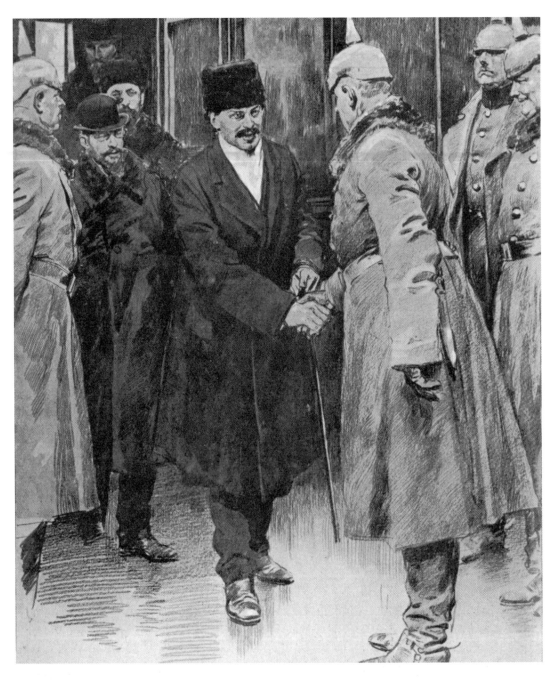

Above: Leon Trotsky arrives at Brest-Litovsk – now Brest in Belarus – and is greeted by German officers. In December 1917 an armistice between Russia's Bolshevik government and the Central Powers (Germany, Austria-Hungary, Bulgaria and Turkey) had ended the fighting between them, allowing negotiations to commence. Trotsky, the People's Commissar for Foreign Affairs, led the Russian delegation and the Brest-Litovsk treaty was signed on 3 March 1918. Although Trotsky had ceded territory in the west, he averted the threat of further action by the Central Powers. This was just as well with the Russians descending into civil war.

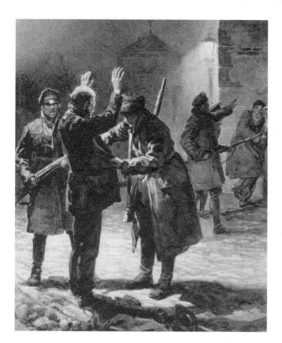

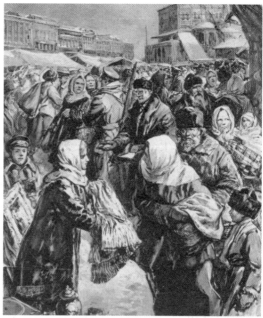

Russia was in turmoil in the post-war years. This selection of contemporary illustrations depicts events during the 'Red Terror', a period of political repression of the masses, generally regarded as continuing throughout the Russian Civil War, 1918–1922. *Above:* 'Red Guard tyranny in the city streets', and peasants bartering personal belongings to obtain food. *Below:* 'Victims of the Bolshevik tyranny, a woman and child collapse from starvation.'

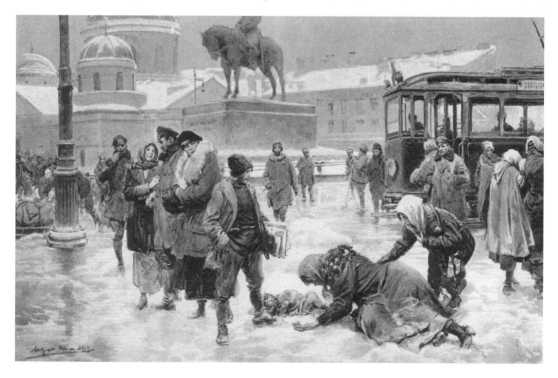

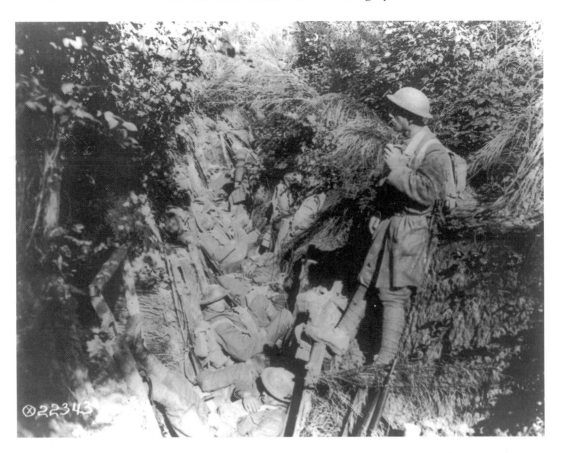

Above: American soldiers in the trenches. The infusion of fresh troops, at a rate of 10,000 a day at its peak by the summer of 1918, tipped the balance in the Allies' favour. In general the US troops were inexperienced and Pershing's tactic of frontal attacks cost them dearly at first. It wasn't just the troops that hastened the end of the war, but also the constant stream of equipment that the Germans could not match. *Below:* An American 14-inch naval railway gun. The first of these would arrive at St Nazaire in August. They were the largest of the Allied guns.

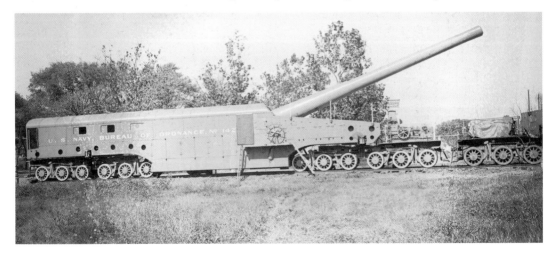

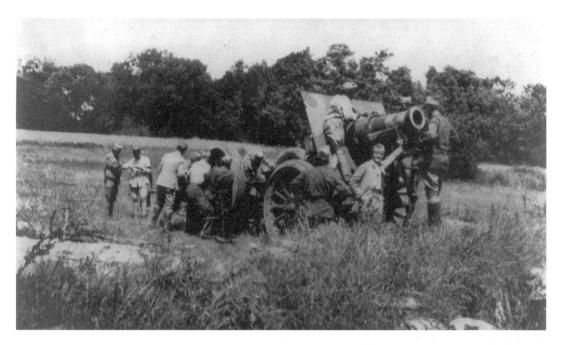

Above: A French heavy howitzer being positioned to support an American attack on Cantigny.
Below: US army trucks camouflaged at a bivouac in France

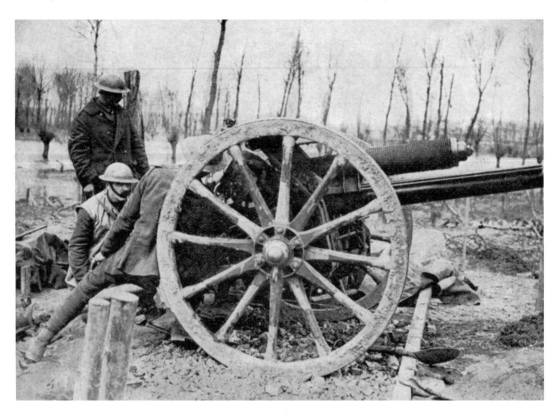

Above: A Royal Horse Artillery Ordnance QF 18-pounder in action in early 1918. *Below:* A German 6-inch gun in a camouflaged emplacement captured by American troops.

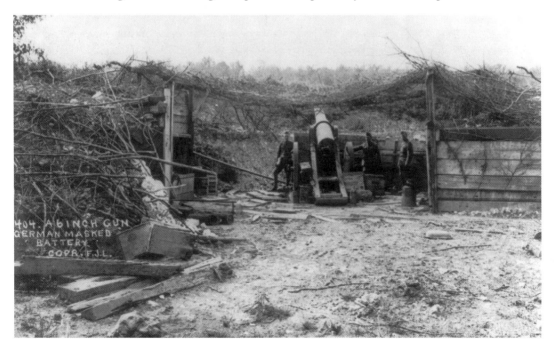

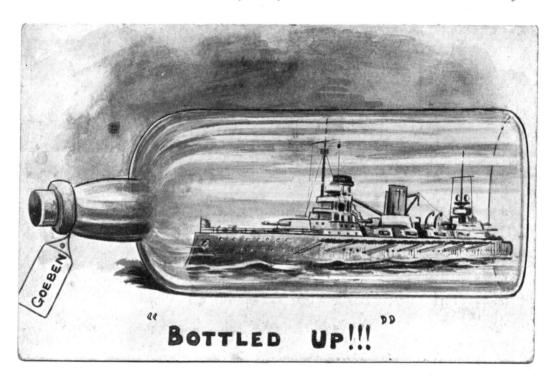

"BOTTLED UP!!!"

Above: SMS *Goeben*, along with SMS *Breslau*, came out into the Aegean on 20 January, after having been bottled up all war. *Goeben* was forced aground and was salvaged by the Turks before she was too badly damaged. This patriotic postcard summed up the fate of *Goeben* and *Breslau* and their wasted war, stuck in Turkey. *Below:* A shipbuilding yard in the USA. The American yards produced standardised designs to make up the numbers lost to U-boats.

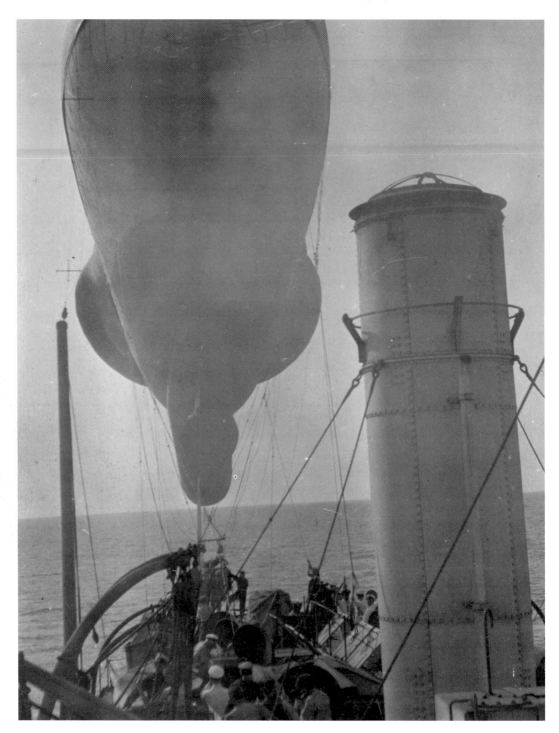

HMS *Wisteria* flying an observation balloon in 1918. These balloons were surprisingly stable while being towed along and gave the crews of the ships an extra ten or twenty miles of sea to search before the horizon. Strings of Cody kites were also used to hoist observers into the air.

FEBRUARY 1918

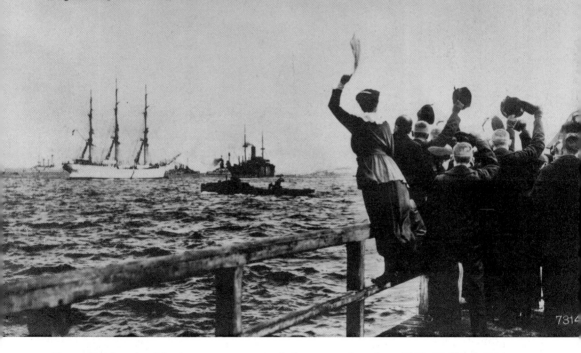

Rückkehr von S. M. H. „Wolf"
nach 15 monatlicher Kreuzfahrt.

Begrüssung des Schiffes beim Einlaufen in den Heimatshafen.

Above: Equipped with six 15-cm guns and four torpedo tubes, SMS *Wolf* left Kiel on 30 November 1916 on a mission to sink as many Allied ships as possible. She had been built for the Hansa Line in 1913 as the *Wachtfels*, and was converted over the autumn of 1916. With a range of 32,000 nautical miles, she carried 8,000 tons of coal as well as supplies for an extended voyage. After 451 days at sea, she returned to Kiel on 24 February 1918 with 467 prisoners and valuable supplies of rare metals, rubber and cocoa. She sank fourteen ships herself and laid minefields that sank another thirteen vessels.

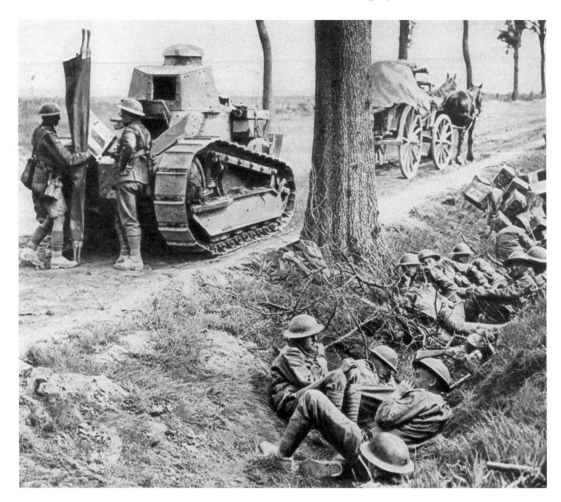

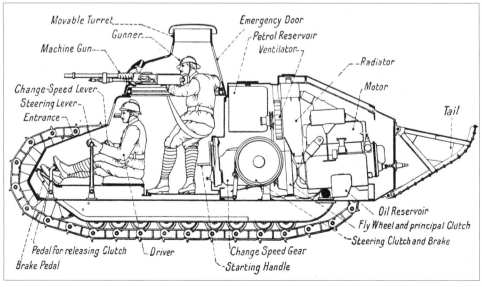

Movable Turret

Gunner

Machine Gun

Change-Speed Lever

Steering Lever

Entrance

Emergency Door

Petrol Reservoir

Ventilator

Radiator

Motor

Tail

Pedal for releasing Clutch

Brake Pedal

Driver

Change Speed Gear

Starting Handle

Oil Reservoir

Fly Wheel and principal Clutch

Steering Clutch and Brake

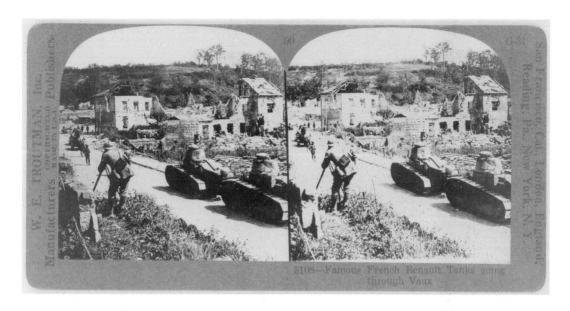

French tanks. *This page, top:* A stereoscopic card of Renault FT17 light tanks passing through Vaux. The two-man FT17 has been described as the world's first modern tank with its innovative rotating turret. 3,000 were built by Renault, mostly in 1918, and more by the Americans under licence as the M1917. The US-built tanks only entered service a month before the Armistice.

Opposite page: FT17s on the Arras–Cambrai road beside Canadian infantry, plus elevational drawing. Note the tail skid to prevent the tank from tipping backwards on rough terrain.

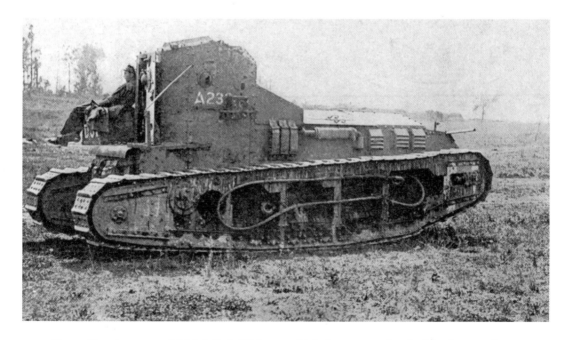

Above: The three-man British Mk A Whippet, which first saw action in March 1918. It was intended to complement the slower heavy tanks. The Whippet remained in service until 1930.

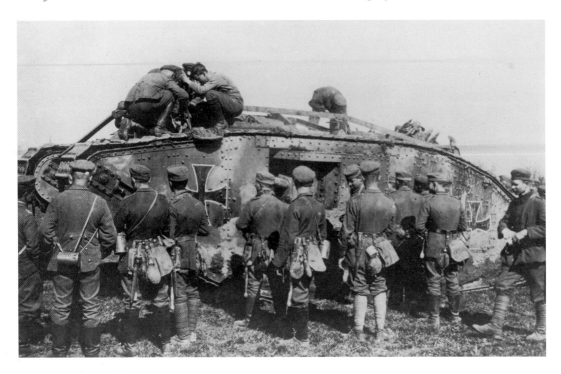

Above: German soldiers working on a captured British tank. *Below:* In the last year of the war tanks were put to a new use carrying supplies over rough ground behind the lines. Here a Mk 1 Supply Tank is escorted by a Scottish working party at Pucquoy, Pas-de-Calais, in August 1918.

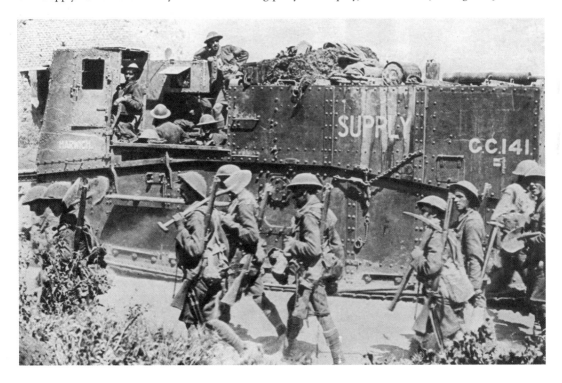

MARCH 1918

Following the British retreat in March, many isolated detachments engaged on special duties behind the lines were called upon to reinforce the depleted ranks of the infantry. Here a small column, without rifles and carrying its portable kit, is shown on the march near La Boiselle in a vain attempt to save the village.

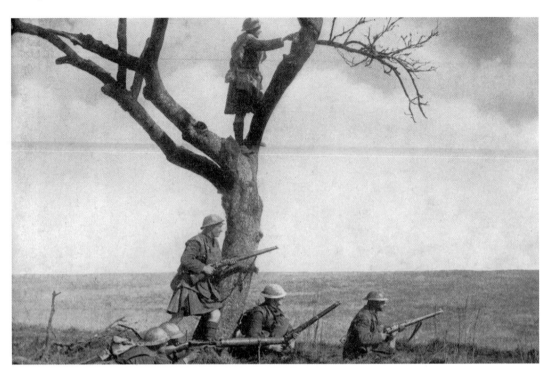

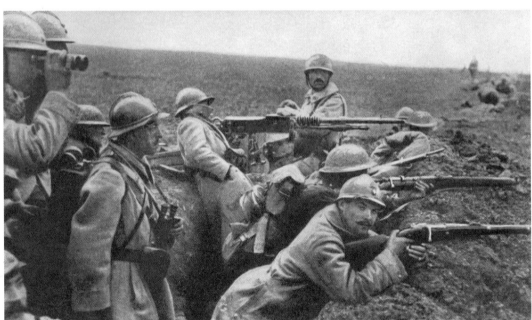

In March 1918, Ludendorff's spring offensive broke through the British line. *Top:* An isolated Lewis gun post of a Highland regiment awaits the arrival of the enemy. *Bottom:* French troops were sent to reinforce the British Fifth Army. Here a French Hotchkiss gun section has taken its place in a shallow British trench dug hastily between Nesle and Montdidier to stem the German advance.

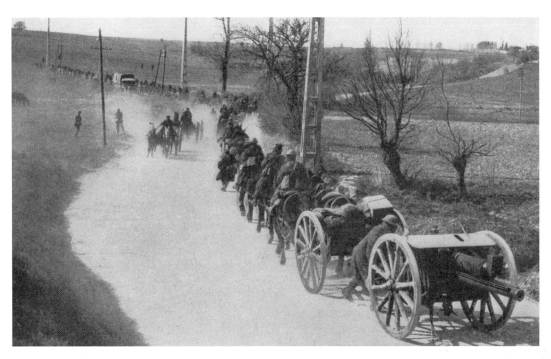

Above: Three days into the German offensive and this battery of 18-pounder guns is being moved towards Maillet. *Below:* After resisting the Germans at Hermies on 26 March, the 17th Division was forced to fall back. All that was left of the division is shown at Hénencourt, where it was reorganised into the 5th Corps Reserve.

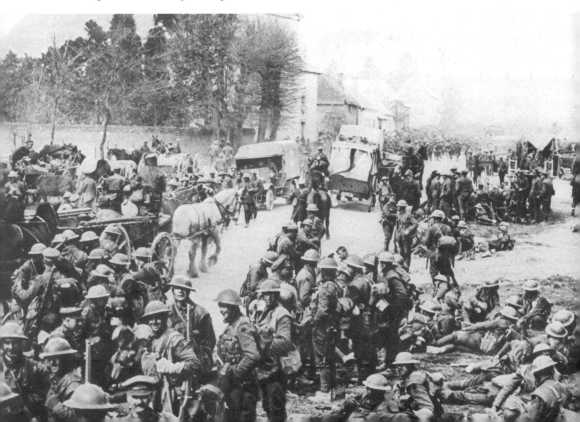

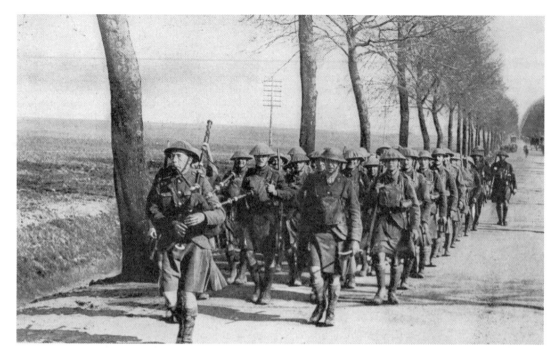

Above: Accompanied by the pipes, men of the London Scottish on the march near Oppy. Part of the 56th Division, they had helped to foil the German attacks on the Arras sector of the line. *Below:* Tanks of the 2nd Battalion Tank Corps and infantry in retreat passing through Aveluy.

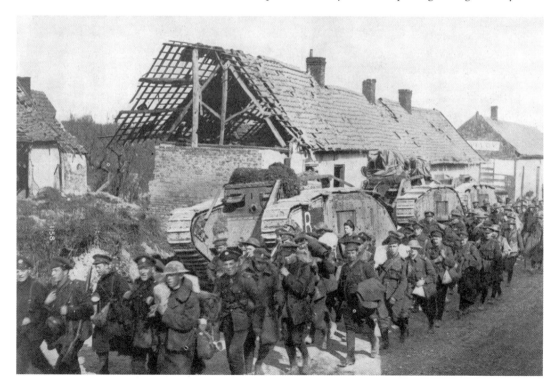

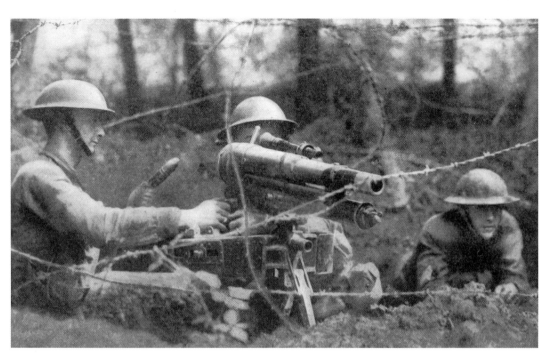

On 20 April 1918, the 26th American Division was defeated at Seicheprey in the Lorraine sector. These soldiers, shown above, are handling a 37-mm gun, known among the Americans as 'trouble makers' because they were easily detected by the enemy. *Below:* Field guns on the final attempt to take Arras on 28 March. It was unusual for the artillery to operate from such unsheltered positions, but the ground in front of Arras is without cover.

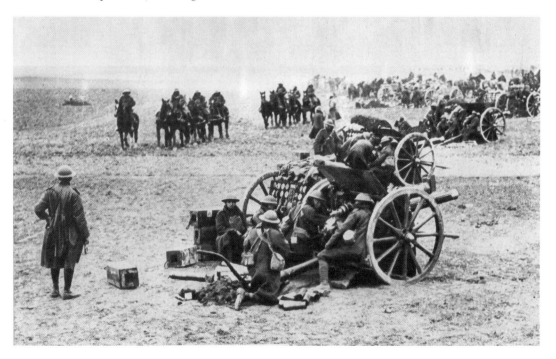

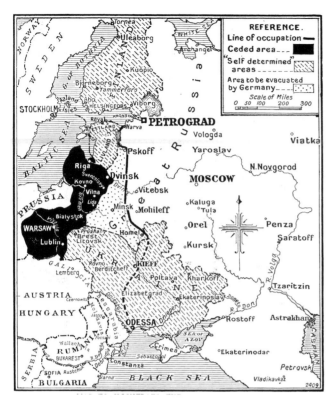

REFERENCE.
Line of occupation ━━━
Ceded area ━ ▬▬
"Self determined" areas
Area to be evacuated by Germany
Scale of Miles
0 50 100 200 300

Left: By the spring of 1918 the map of Europe was undergoing rapid changes in the light of the German offensive on the Western Front and, in the east, treaties between Germany and Russia. This map shows the results of the Brest Treaty of 3 March. The agreed line west of which Russia renounced territorial rights runs west of Revel and down through the Gulf of Riga, then follows the Dvina before curving south-west across the Niemen down to the northern Ukraine border. The black line marks the German line of occupation, and the black area indicates the ceded territories.

Below: A scene during the Battle of St Quentin on 23 March. In the street in Nesle, where the 20th Divisional Headquarters was established, a meagre barricade is hastily assembled with any materials that come to hand.

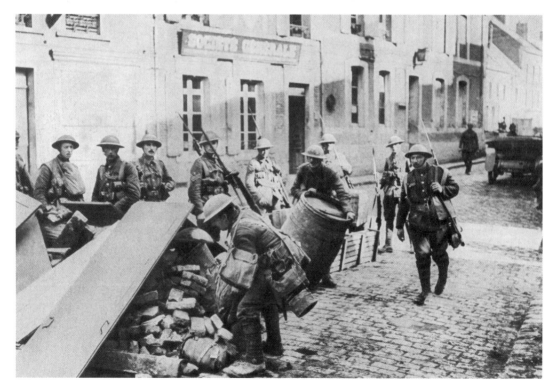

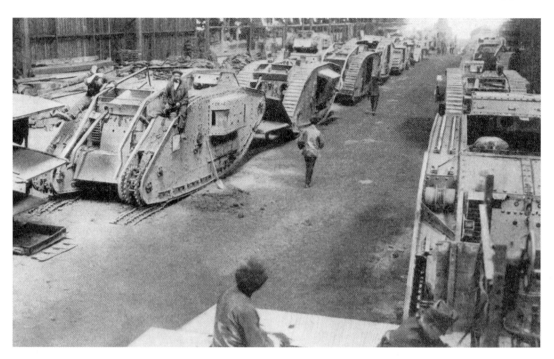

The initial success of Germany's spring offensive not only saw the occupation of territory previously held by the Allies, but also the capture of large quantities of munitions and equipment. *Above:* This large workshop behind the German lines is full of captured British tanks that had been taken in March. It was customary for both sides to reuse such captured equipment. *Below:* British 6-inch howitzer being examined by its new owners at Hendecourt. The British and French lost more than 1,000 guns in the last ten days of March alone.

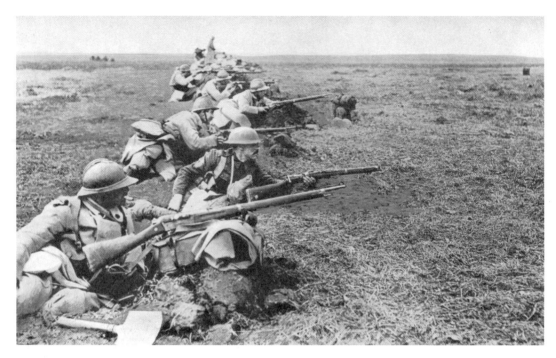

Above: British and French troops side by side in hastily dug rifle pits, in a desperate attempt to hold back the German advance at the Somme crossings. *Below:* A French heavy gun on a railway mounting at Vienne-le-Château on the Marne. Well-camouflaged, it is part of the measures that would turn the Allied defensive position into one of attack.

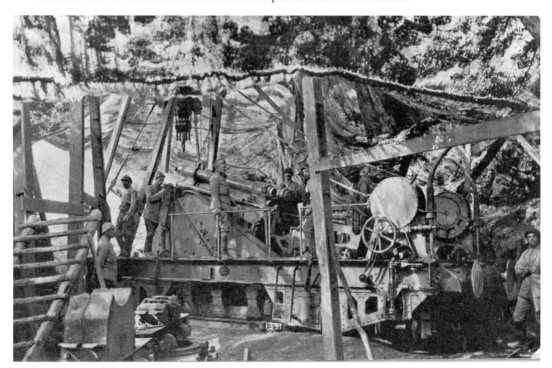

APRIL 1918

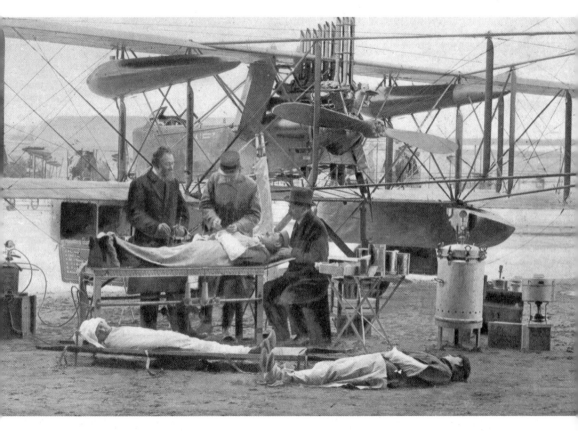

Above: A French experiment, the 'Aerochir' was intended as a hospital aircraft for the Red Cross. Supposedly it could take all sorts of specialist equipment, such as X-ray machines and surgical instruments and materials, direct to where it was needed.

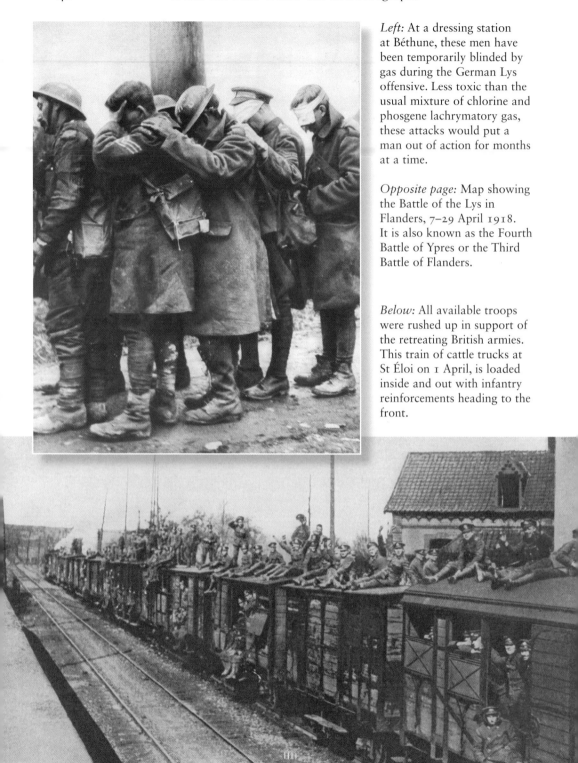

Left: At a dressing station at Béthune, these men have been temporarily blinded by gas during the German Lys offensive. Less toxic than the usual mixture of chlorine and phosgene lachrymatory gas, these attacks would put a man out of action for months at a time.

Opposite page: Map showing the Battle of the Lys in Flanders, 7–29 April 1918. It is also known as the Fourth Battle of Ypres or the Third Battle of Flanders.

Below: All available troops were rushed up in support of the retreating British armies. This train of cattle trucks at St Éloi on 1 April, is loaded inside and out with infantry reinforcements heading to the front.

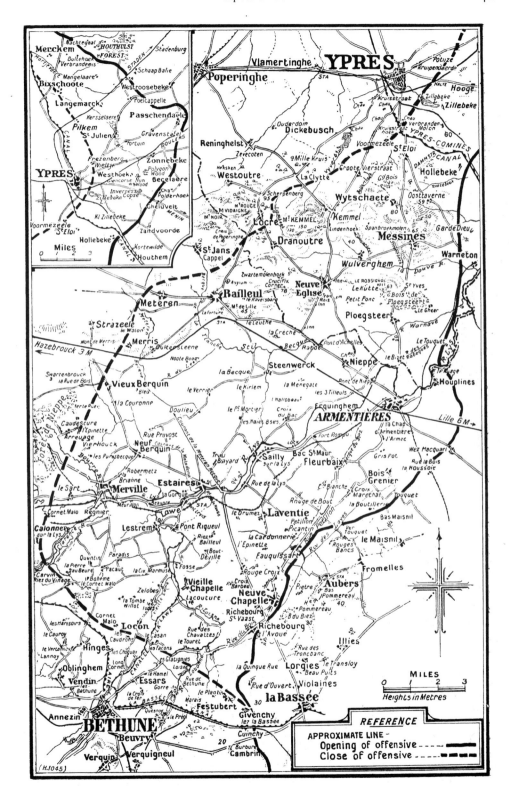

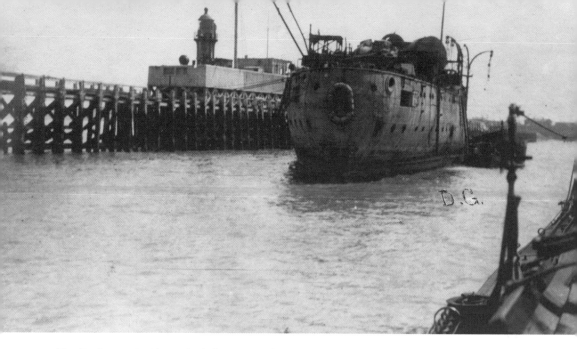

The Zeebrugge Raid was hailed as a British success with numerous Victoria Crosses awarded for the action. In reality, the attack, designed to block the ports of Zeebrugge and Ostend was an abject failure with many British casualties and few German, with blockships sunk in the wrong places. *Below:* HMS *Vindictive*, an outdated cruiser, was used in the first attack on Zeebrugge and this view shows the damage to her funnel after the attack.

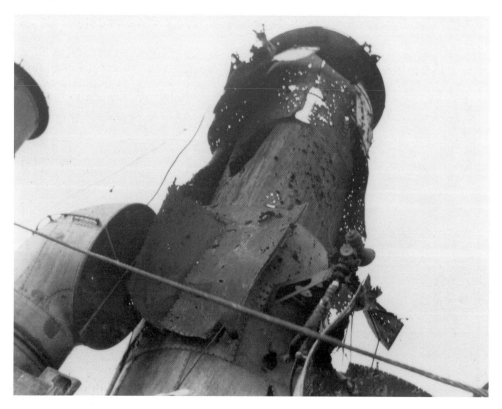

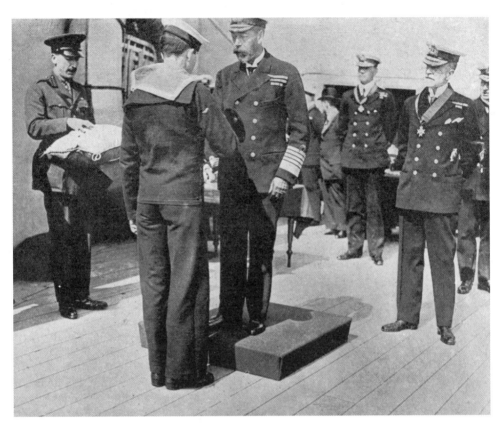

Above: The King decorates a seaman after the Zeebrugge Raid. On the right is Admiral Pakenham wearing the newly-bestowed ribbon and cross of a KCB. *Below:* Blockships, including HMS *Iphigenia*, litter the seaway into Zeebruggee. They were intended to block the port to the submarines that used it, but at high tide it was still possible to navigate the canal.

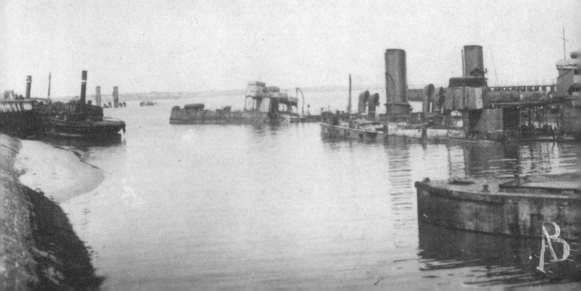

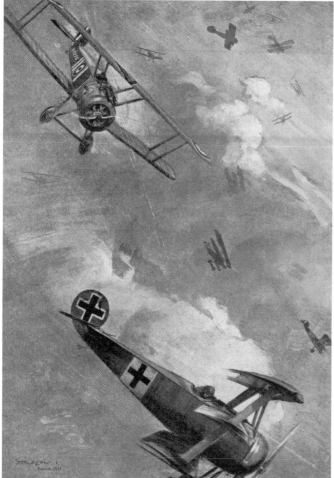

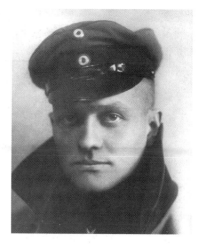

Germany's Manfred von Richthofen, above, was the most successful ace of the First World War and is credited with eighty air combat victories. Known as the 'Red Baron', his reign came to an end on 21 April 1918 when his Fokker Dr.I was attacked while flying over Morlancourt Ridge, near the Somme, by a Sopwith Camel piloted by a Canadian pilot. Richthofen was killed by a single bullet, although there is some controversy regarding who fired the shot with suggestions that it may have been fired from the ground.

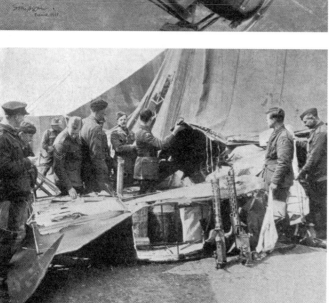

Left: Allied personnel inspect the remains of Richthofen's aircraft. He had managed to make a landing and it was subsequently pulled apart by souvenir hunters.

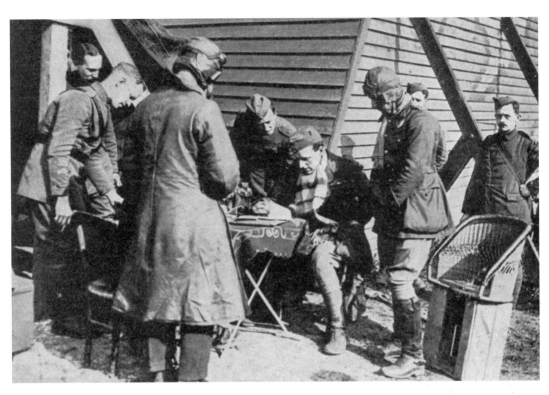

Above: Allied pilots bring in their reports after a mission over the lines. *Below:* Aircraft of the US Air Service in France. This was formed in 1918 as part of the American Expeditionary Force to provide tactical support. In 1920 the Air Service became a branch of the US Army.

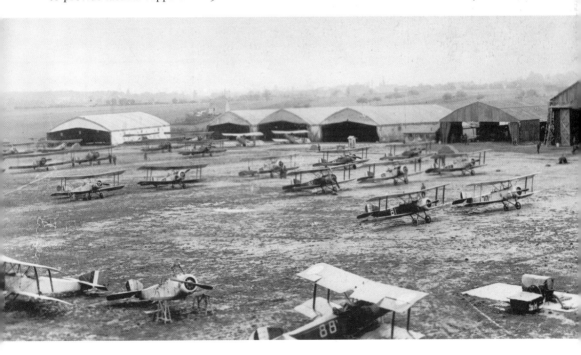

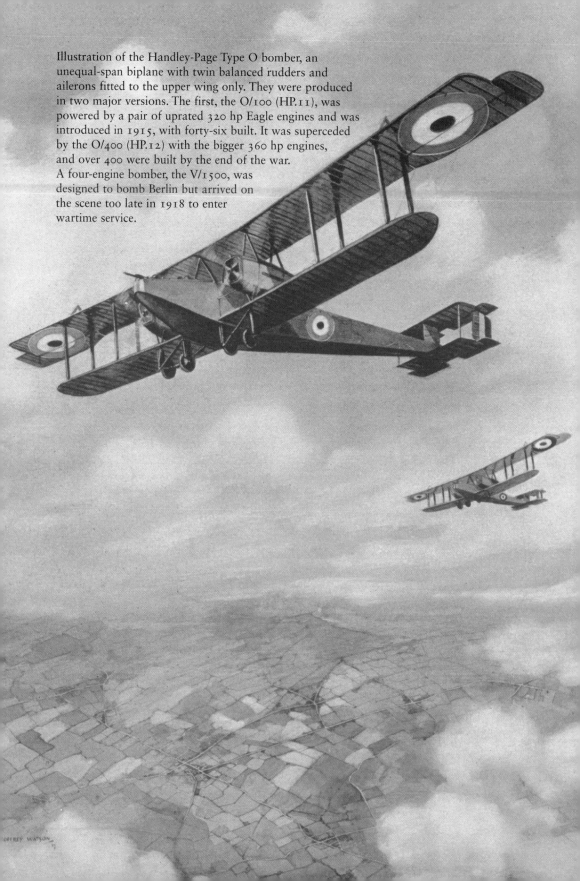

Illustration of the Handley-Page Type O bomber, an
unequal-span biplane with twin balanced rudders and
ailerons fitted to the upper wing only. They were produced
in two major versions. The first, the O/100 (HP.11), was
powered by a pair of uprated 320 hp Eagle engines and was
introduced in 1915, with forty-six built. It was superceded
by the O/400 (HP.12) with the bigger 360 hp engines,
and over 400 were built by the end of the war.
A four-engine bomber, the V/1500, was
designed to bomb Berlin but arrived on
the scene too late in 1918 to enter
wartime service.

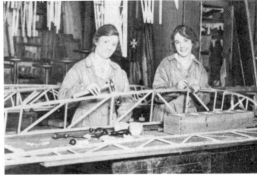
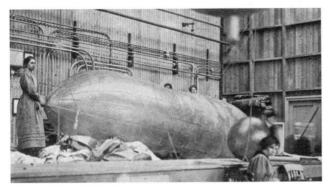
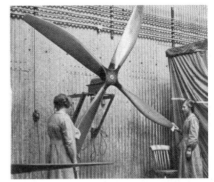
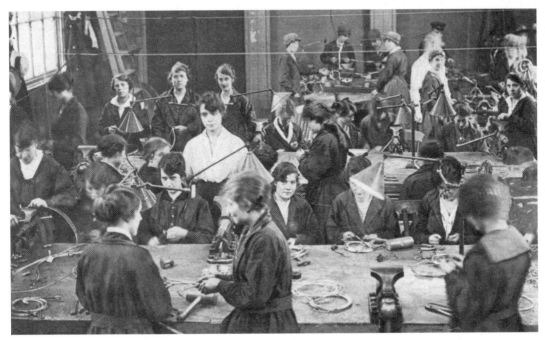

Top: Two images showing construction of a wing, painting, and one of the ribs for an aircraft. The remaining series of views shows women workers in the Royal Naval Air Service (RNAS) producing components for non-rigid airships. These saw valuable service in coastal patrols, convoy escort duties and submarine spotting.

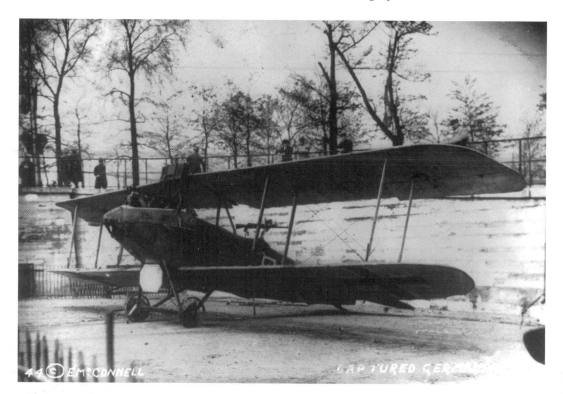

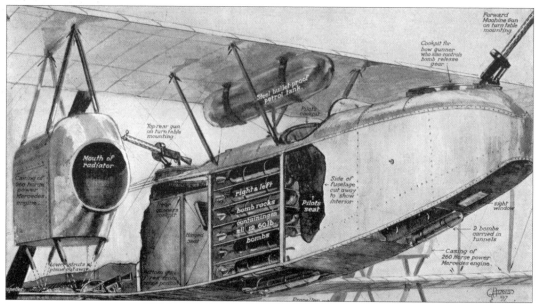

German aircraft. *Top:* A captured biplane put on display in 1918. *Bottom:* Cutaway detail of a Gotha showing the position of the bomb racks, the 260 hp Mercedes engines, bulletproof fuel tank and the forward gun turret. The Gotha G.V. series were long-range heavy bombers operated by the Imperial German Air Service, mostly on night raids. The Gotha had first entered service in August 1917 and 205 were built.

MAY 1918

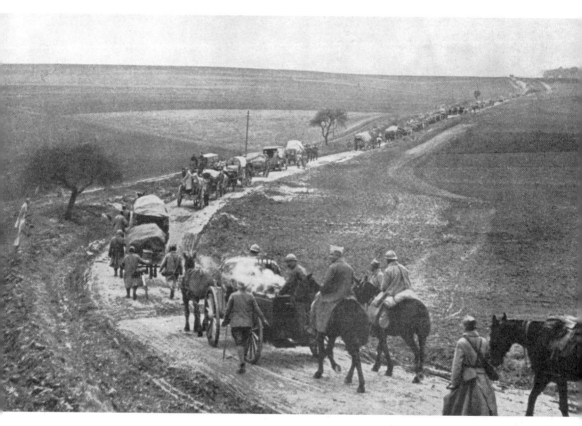

Above: A long train of French artillery passes through a stretch of bare country on the road to Amiens. An important railway junction, Amiens became an important link in the Allied chain of communication in northern France. In April the Germans had come within eight miles of its capture.

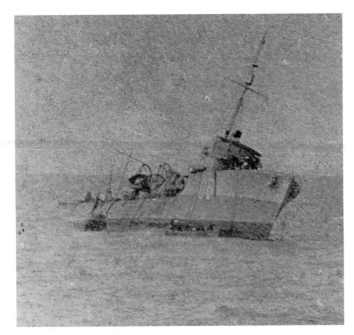

Left: On 14 May 1918, HMS *Phoenix* was torpedoed in the Adriatic. The men in the whaler are passing a towrope from HMAS *Warrego* but she sank later that day, capsizing within a few miles of safety. She was the only British warship of the war sunk by an Austro-Hungarian warship. *Phoenix* had taken part in the battles of Jutland, Dogger Bank and Heligoland Bight.

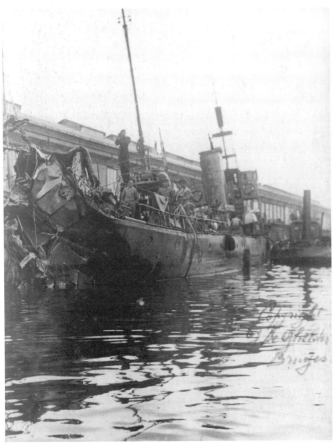

Left: Damaged German destroyer after the Ostend raid.

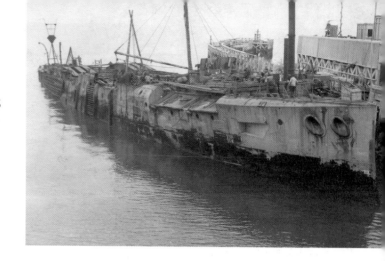

Right, top and middle:
In May 1918, an attempt
was made again to blockade
Ostend, this time using HMS
Vindictive from the previous
attempts at Zeebrugge. This
raid was more successful
than the first Ostend Raid,
with HMS *Vindictive* being
sunk and partially blocking
the canal to Brugges. The
Vindictive was eventually
salvaged and her bow
remains today in Ostend as
a monument to the many
men who died in the attacks
on Ostend and Zeebrugge.
Hailed as huge victories in
the UK at the time, they were
simply glorious failures.

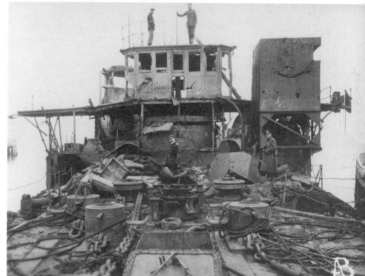

Below: The wreck of HMS
Vindictive, the obsolete
Arrogant-class cruiser.

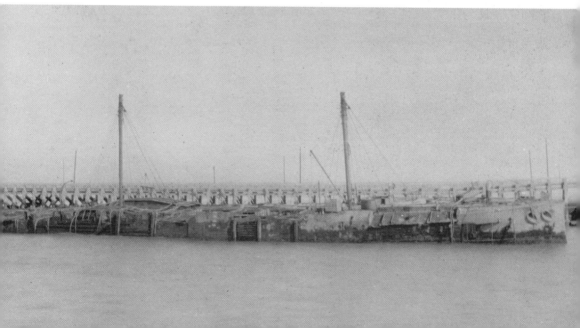

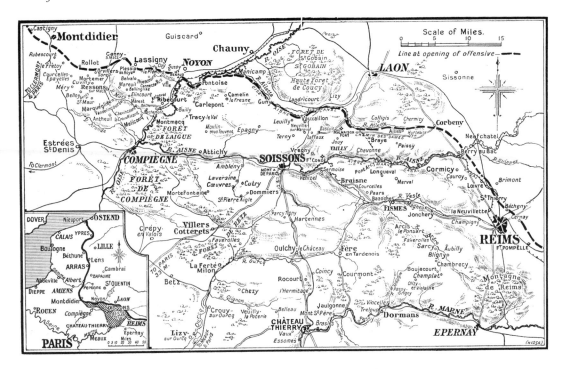

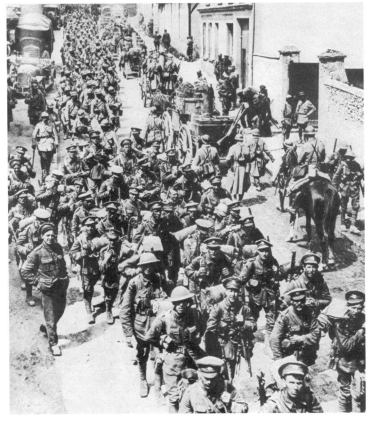

Above: The German offensive of May and June 1918. The River Aisne runs east–west through Soissons, and the Marne is at the bottom of the map.

Left: During the Third Battle of the Aisne, which opened in May 1918, both the French and British armies were forced to fall back. Here French and British infantry are seen marching together through Passy-sur-Marne on 28 May.

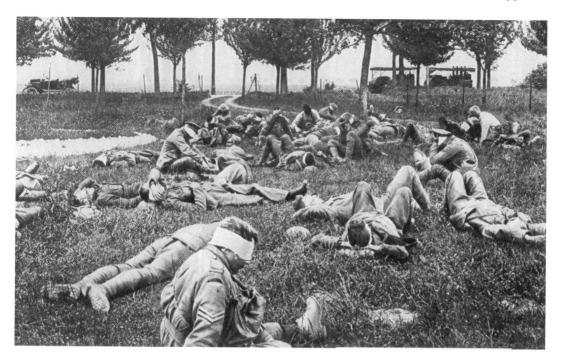

Above: 27 May, 1918. British troops recovering at an overcrowded dressing station in the Bois l'Abbé following a German gas attack on Amiens. *Below:* These are Allenby's men who, having fought in Palestine and Egypt, were transferred via Italy to France to bolster the Allied forces. Clearly the transport ship was incredibly overcrowded on the voyage from the Mediterranean.

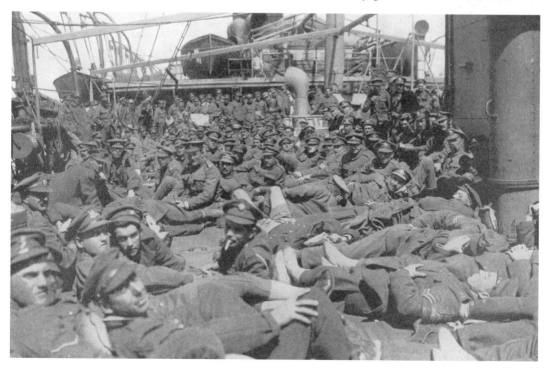

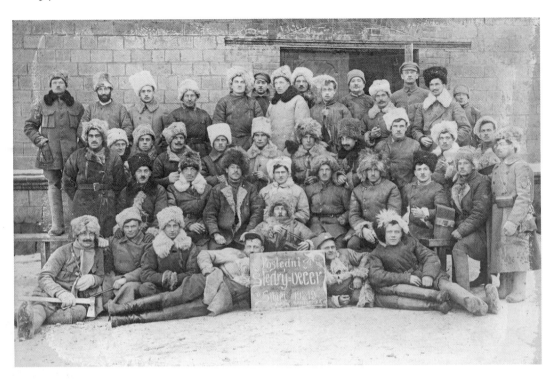

Above: The Czechoslovak Legion were volunteers, composed predominantly of Czechs and Slovaks fighting with the Allies, or Entente Powers. They took part in several battles in Russia and in 1918 fought the Bolsheviks in Siberia. *Below:* A scouting party in Russia's Lower Volga.

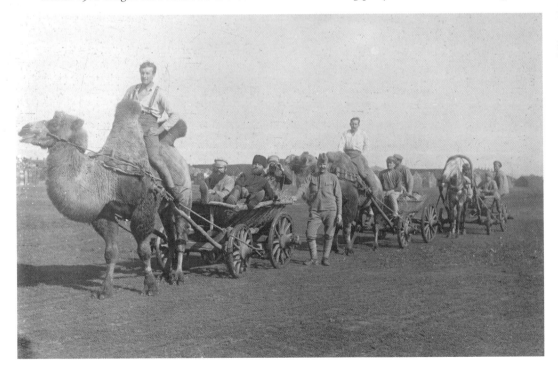

JUNE 1918

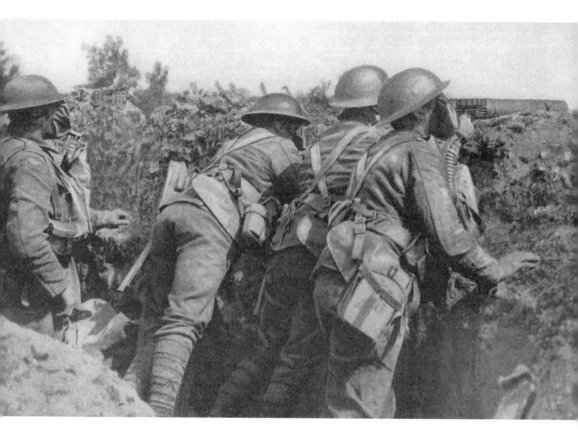

Above: During June the British made a series of local attacks on the Lys front. Here men of a
12th Royal Scots Lewis gun section are manning a trench near Méteren. They are wearing box
respirators to protect them from gas attack. Méteren fell to the 9th division on 19 July.

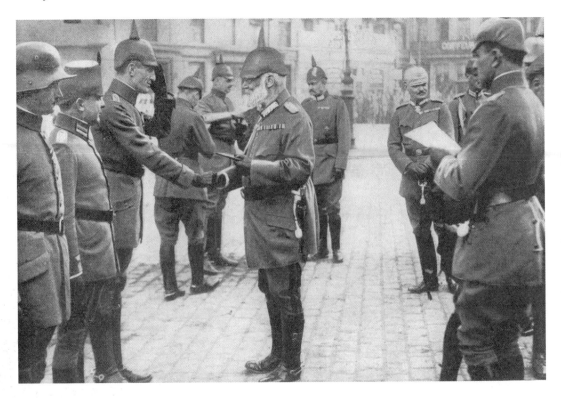

Above: In the main square of a French town these German soldiers are receiving decorations from King Ludwig of Bavaria in June 1918. These must have been among the last awards to be given to German personnel for valour in victory.

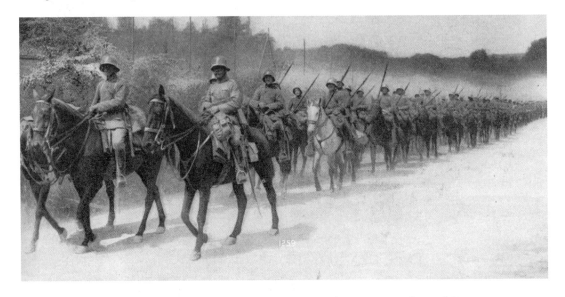

Above: Near Vailly, on the Aisne front, in June 1918 the German Lifeguard Dragoons are shown advancing. The initial success of the German spring offensive enabled the cavalry to be exploited to a greater extent than at any period since the opening of the war.

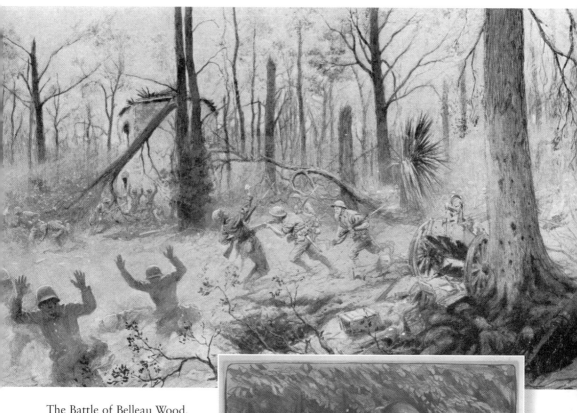

The Battle of Belleau Wood, near the Marne river, took place from 1 to 26 June with the objective of taking the German position. It was the first real experience of battle for the men of the US Marine Corps, who fought alongside British and French forces. The Marines suffered almost 10,000 casualties in the fierce fighting, and 1,811 men were killed. Many are buried in the nearby Aisne-Marne American Cemetery. The action gave rise to many accounts of the Americans' bravery as shown here.

Top: 'American Marines clearing Belleau Wood with the bayonet.'
Right: A graphic image of hand-to-hand combat at Belleau Wood.

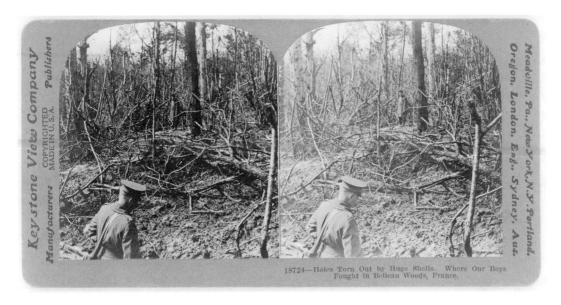

Above: Keystone stereoscopic card showing Belleau Woods with huge holes made by the shells.

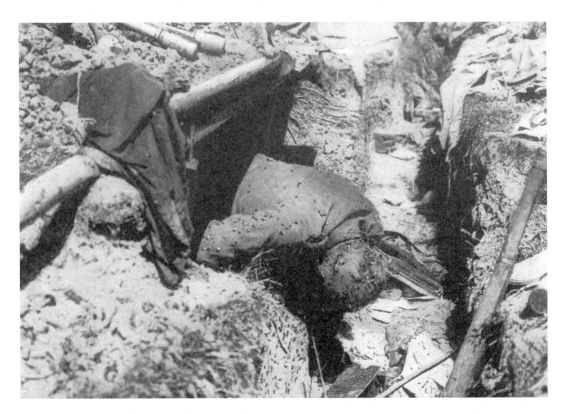

Above: This German soldier was killed in the action at La Becque on 28 June, as he was emerging from a dug-out. This shocking photograph was taken a few days later when the trench had been captured by the King's Own Scottish Borderers.

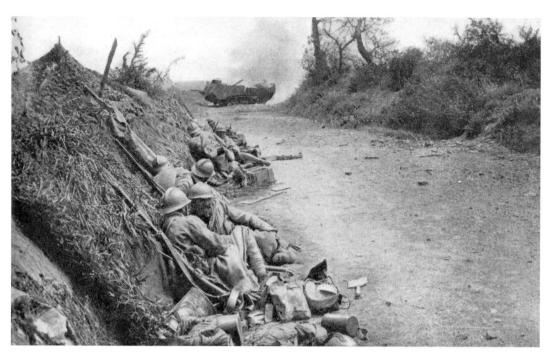

On 11 June, near Courcelles, the French struck back against the Germans. These photographs show the French troops halted in the supposed shelter of a sunken road, but as the lower image shows it became a death trap under an onslaught of German artillery. Note the French Saint-Chamond heavy tank burning in the background in the upper photograph.

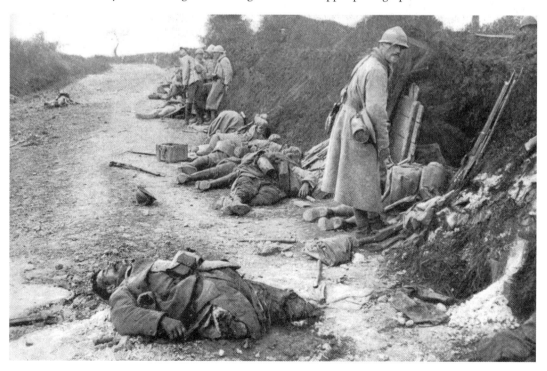

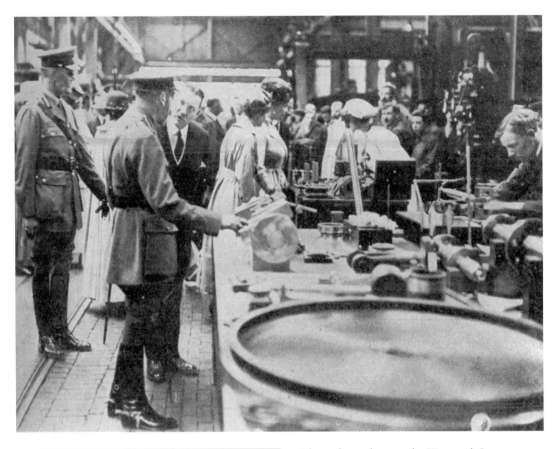

Throughout the war the King and Queen undertook countless official tours to boost morale on the Home Front. They are shown above on an official tour of an aircraft factory at Bedford in June 1918.

A GOOD RIDDANCE.

[The King has done a popular act in abolishing the German titles held by members of His Majesty's family.]

Left: It wasn't until 1917 that the pressure of anti-German feelings persuaded the King to sweep away the ties with his German cousins. All German titles were relinquished and the House of Saxe-Coburg-Gotha became the more British-sounding House of Windsor. This *Punch* cartoon was published in June 1917.

JULY 1918

Above: Members of a concert paty at a convalescent depot at Trouville. Despite appearances, all of the troupe are men as women were not allowed to perform close up to the front line.

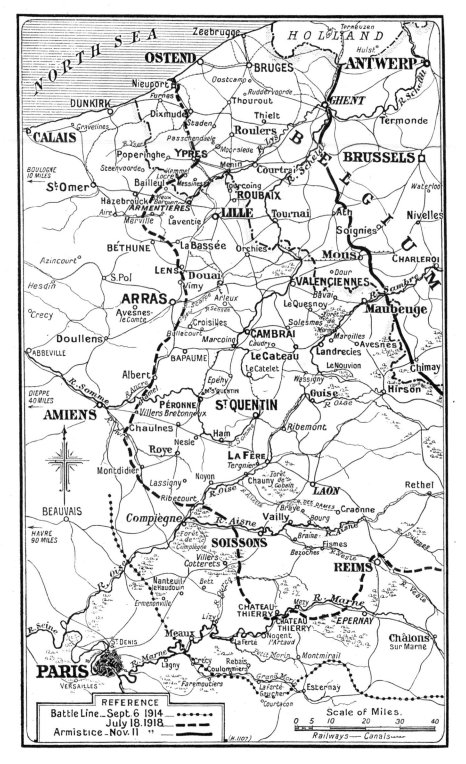

Above: The theatre of war on the Western Front, showing the battle lines in 1914 and 1918.

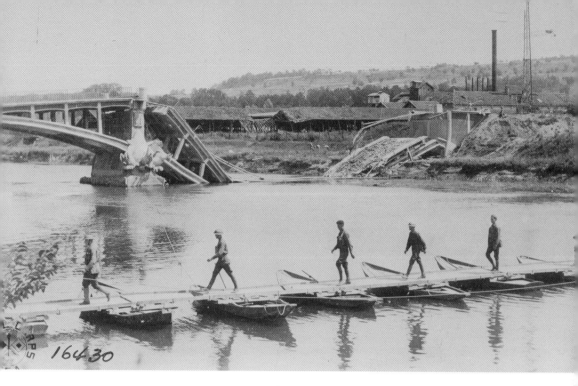

Above: With the main bridge wrecked, this simple pontoon bridge provides a temporary crossing over the Marne on 20 July 1918.

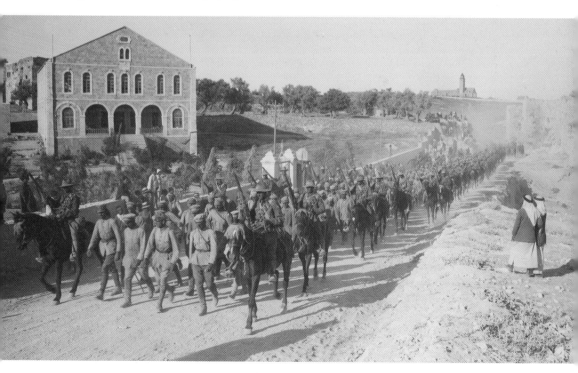

Above: In the Middle East, German and Turkish prisoners being marched out of Jericho on 15 July 1918. Jericho had been captured by General Allenby's forces back in February.

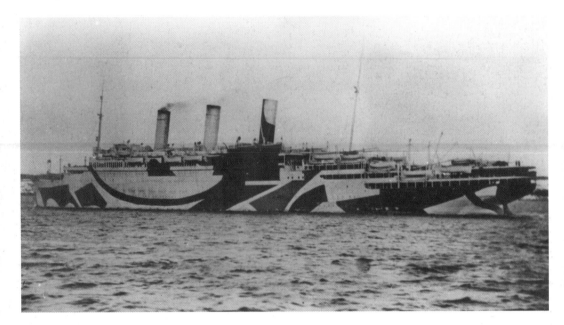

With the loss of HMHS *Britannic* in November 1916, the White Star Line had a crew and no ship. This was solved by the *Justicia*, which had been under construction as the *Statendam* for Holland America Line and, after the loss of the *Lusitania*, had been intended for Cunard. She could carry some 4,000 troops and was originally painted grey and then in this dazzle scheme. Sailing empty from Belfast to New York on 19 July 1918, *Justicia* was torpedoed by UB-64. She took on a list and was hit by three other torpedoes. Somehow, she managed to stay afloat and her destroyer escort chased the submarine away. The next day, she was found by UB-124 and *Justicia* was hit by two more torpedoes. UB-124 was sunk and by lunchtime *Justicia* had rolled over and sank.

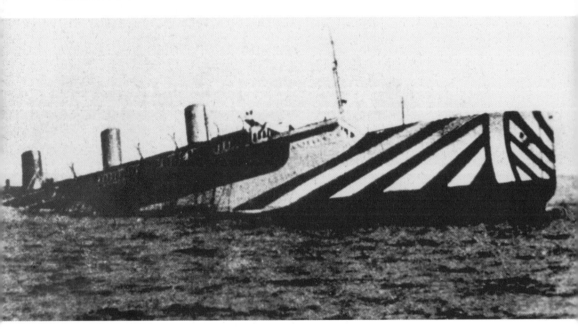

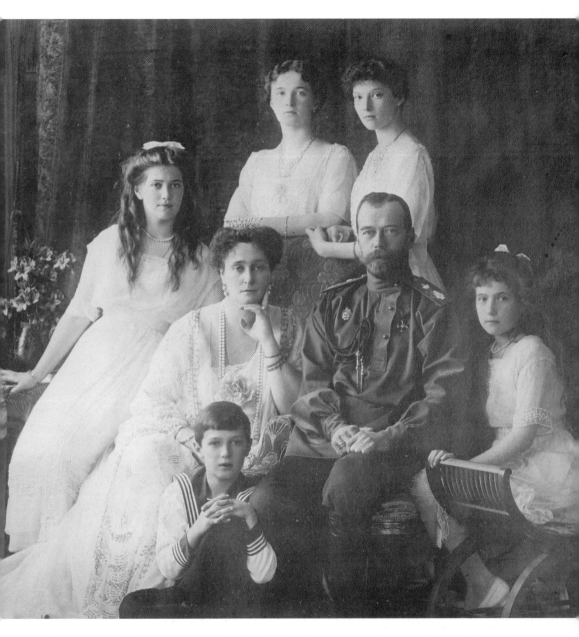

Above: On 16 July 1918, Russia's Bolsheviks put Czar Nicholas II and his family to death. The Romanovs were shot and bayoneted in a celler in Ekatrinburg in the fiercely pro-Bolshevik area in the Urals. Since his abdication in 1917 the Czar had been living in relative comfort in Tobolsk in northern Siberia. But the move to Ekatrinburg brought about the sequence of events that resulted in his entire family, plus the family doctor, valet, cook, parlourmaid and even their dog, being brutally executed. For years rumours persisted that Grand Duchess Anastasia Nikolaevna, the youngest daughter, shown on the right of this photograph, had escaped and survived. Then in 1991 the location of the mass grave was revealed and forensic testing has since confirmed that it did contain the remains of the royal family, provingly conclusively that all four grand duchesses had been killed in 1918.

The First World War saw a remarkable shift in the role of women, who served in their thousands both on the Home Front, in the munitions factories, on the farms and in the auxiliary services, as well as in France behind the lines. This illustration shows munitions workers filing into the canteen for dinner. However, the reality of working conditions in the factories was not so rosy; it was hard and often dangerous work with the ever-present risk of explosions and the long-term harm to their health caused by the chemicals used to fill the shells.

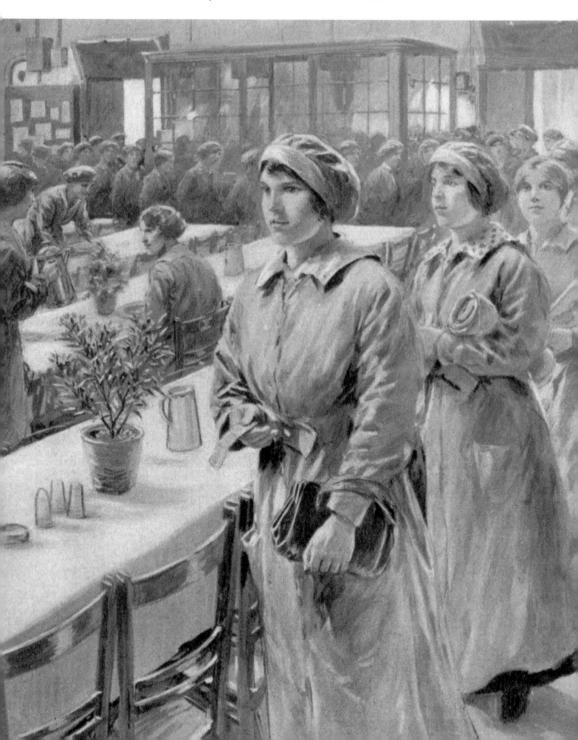

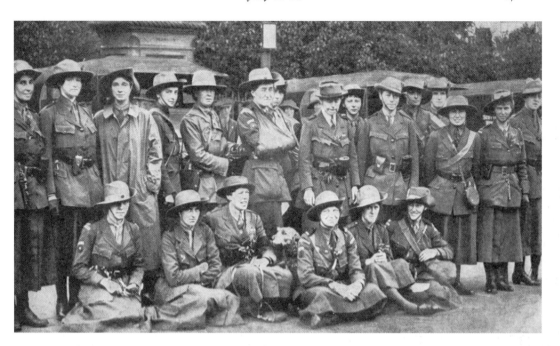

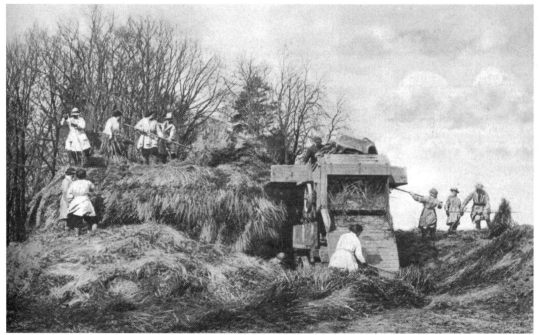

Top: A section of the Women's Reserve Ambulance Corps, serving with the Scottish Women's Hospitals, on parade with their vehicles in London before driving to Liverpool, where they would embark for the Eastern Front. *Bottom:* While the Women's Land Army is widely associated with the Second World War, we should not forget that an earlier generation of female farm workers had been doing their bit in the 1914–18 conflict to maintain the food supply for the nation. These 'Land Girls' are shown during training on a farm in Buckinghamshire.

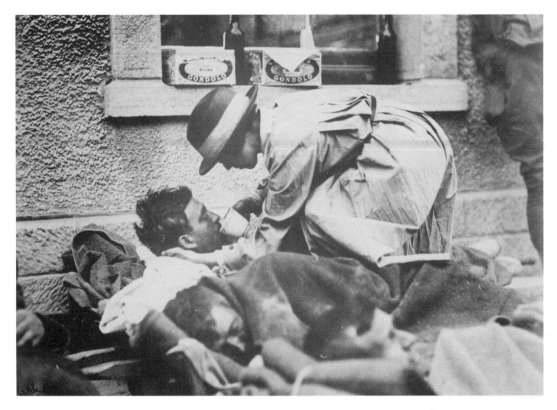

Above: A Red Cross volunteer – identified in this official photograph as Mrs Hammond – gives water to wounded British soldiers at Montmirail railway station near the Marne, north-eastern France, 31 May 1918.

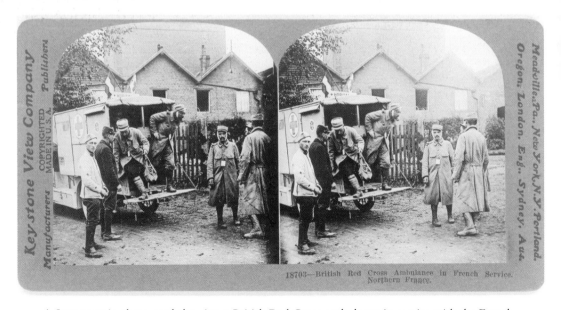

A Stereoscopic photo card showing a British Red Cross ambulance in service with the French.

AUGUST 1918

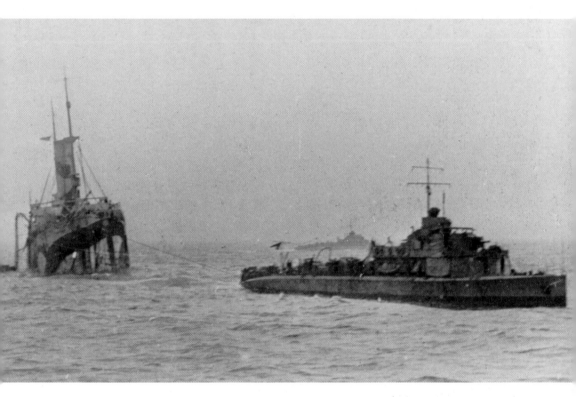

Above: HMS P32 towing SS *Waipara* after she was torpedoed on 4 August 1918. The British India Line cargo ship was used as a cadet training ship and one of the young cadets was killed after the ship was torpedoed.

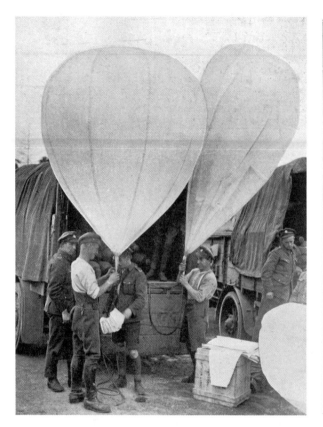

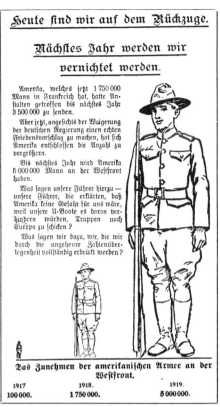

Heute sind wir auf dem Rückzuge.

Nächstes Jahr werden wir vernichtet werden.

Amerika, welches jetzt 1 750 000 Mann in Frankreich hat, hatte Anstalten getroffen bis nächstes Jahr 3 500 000 zu senden.

Aber jetzt, angesichts der Weigerung der deutschen Regierung einen echten Friedensvorschlag zu machen, hat sich Amerika entschlossen die Anzahl zu vergrößern.

Bis nächstes Jahr wird Amerika 5 000 000 Mann an der Westfront haben.

Was sagen unsere Führer hierzu — unsere Führer, die erklärten, daß Amerika keine Gefahr für uns wäre, weil unsere U-Boote es daran verhindern würden, Truppen nach Europa zu schicken?

Was sagen wir dazu, wir, die wir durch die ungeheure Zahlenüberlegenheit vollständig erdrückt werden?

Das Zunehmen der amerikanischen Armee an der Westfront.

1917.	1918.	1919.
100 000.	1 750 000.	5 000 000.

Above: Inflating the paper balloons, and an example of a leaflet warning of the growing strength of the American Army on the battlefield. *Opposite:* Dropped just before the Armistice, this facsimile newspaper shows the Kaiser driving the German people over the edge of a cliff.

The War of Words

Although we are familiar with aircraft dropping propaganda leaflets behind enemy lines, the story of the propaganda balloons of the First World War is not so well known. The notion of delivering propaganda by balloon dates back to the siege of Milan in 1848, but an official propaganda branch within Britain's Military Intelligence didn't come about until 1916. Initially aircraft were used, mostly dropping the leaflets while performing their ordinary duties. The German government strongly objected to to these 'inflammatory writings' and warned that any captured airman known to have dropped propaganda could face the death sentence. Against this background the British boffins developed an alternative delivery method using disposable paper balloons. These were 8 feet high, with a volume of 100 cubic feet, and inflated with hydrogen they could carry between 500 and 1,000 leaflets each. A slow-burning wick ensured that the balloons dropped their loads behind enemy lines. Similar propaganda balloons were used in the Second World War, during the Cold War and in other conflict zones since.

30

Heer und Heimat

November 1918. 10 Pfg.

Verhängnisvolle Fahrt.

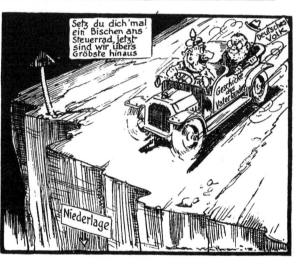

Am Steuerrad.

„Ich wollte das deutsche Volk würde in größerem Maße als bisher mitarbeiten die Geschicke des Vaterlandes zu gestalten" — Der deutsche Kaiser an den Grafen Hertling.

Setz du dich 'mal ein Bischen ans Steuerrad, jetzt sind wir übers Gröbste hinaus

deutsches Volk

Geschicke des Vaterlandes

Niederlage

Dem Führer wird's unheimlich —

WILHELM WIRD GEKÜNDIGT

GESCHICKE DES VATERLANDS

Wird der Chauffeur herausgeschmissen?

Und er hatte Grund dazu!

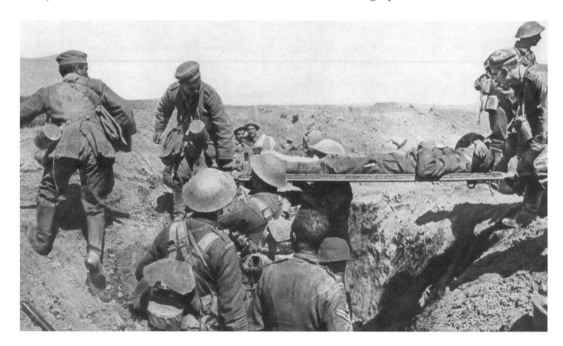

Above: German prisoners, under British supervision, are carrying wounded soldiers across an old German trench after the capture of Moyenneville, 7 miles south of Arras. 21 August was the opening day of the British August offensive.

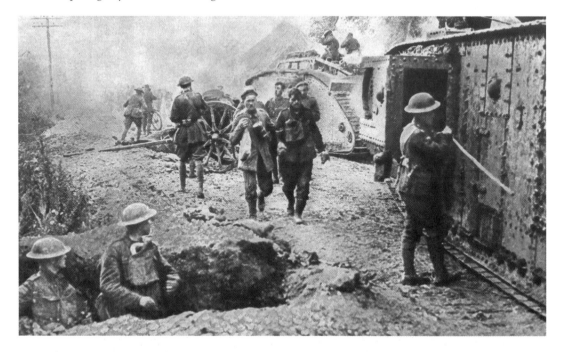

Above: Tanks, manned by Canadians, are moving up to take part in the attack on Arras on 8 August following several months on the defensive. German prisoners pass on their way to captivity in the village of Hourges on the Amiens–Roye road.

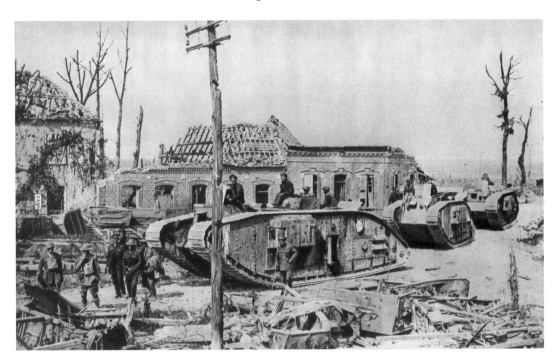

Above: Mark V tanks enter the ruined village of Méaulte on 22 August shortly after its capture by the Royal Berkshire Regiment. *Below:* A sign of the changing fortunes of war with some of the 13,000 prisoners captured near Amiens on 8 August. Many of them have been corralled into a vast open-air barbed wire cage, visible in the background.

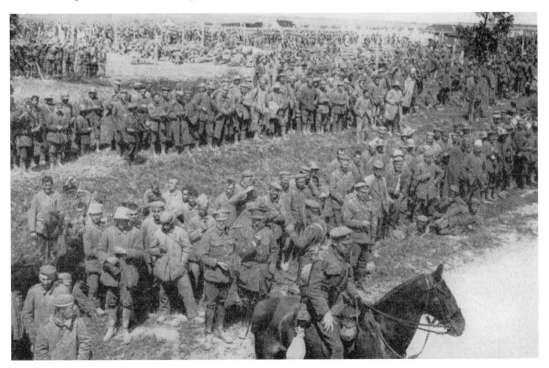

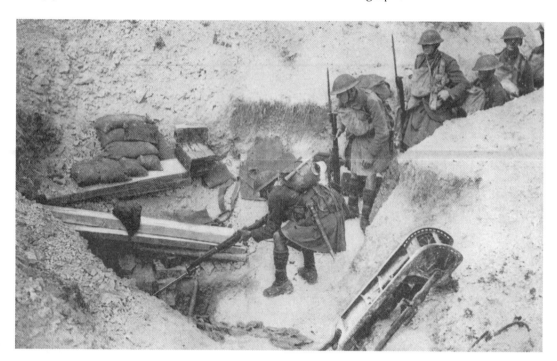

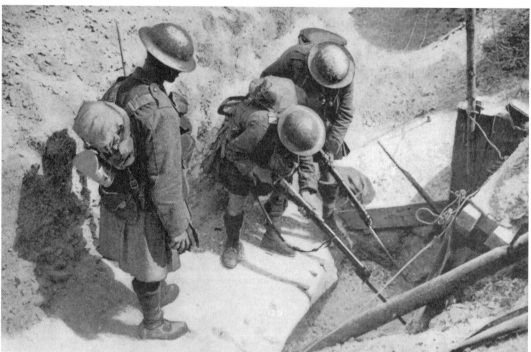

Two photographs taken immediately after the capture of Greenland Hill in the Battle of the Scarpe on 29 August. They show men of the 6th Scottish Higlanders firing down into enemy dug-outs in order to flush out any German soldiers taking refuge within them. The labyrinthine nature of the German underground systems made them both difficult and dangerous to clear.

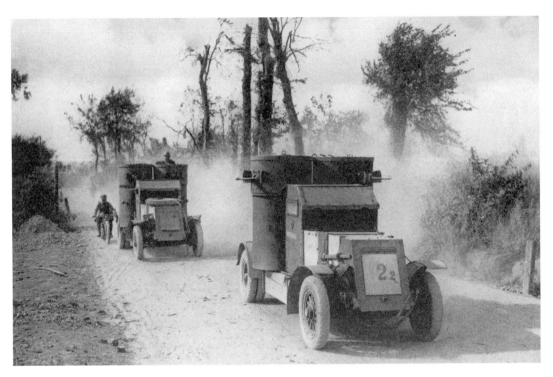

Above: British armoured cars at Biefvilliers at the end of August, seen on reconnaissance duties. Biefvilliers, in the Somme area, was taken by the New Zealand 37th Division on 24 August. *Below:* Sailly-le-Sec was the farthest point reached by the Germans north of the Somme. German prisoners are shown lining up, waiting to act as stretcher-bearers.

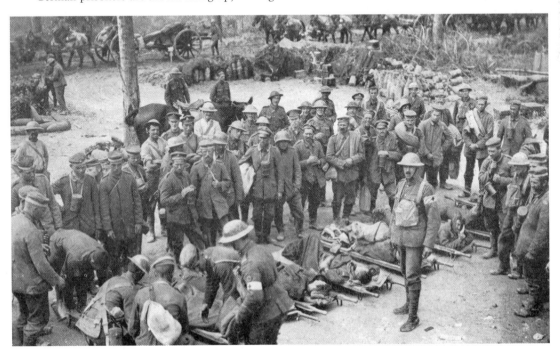

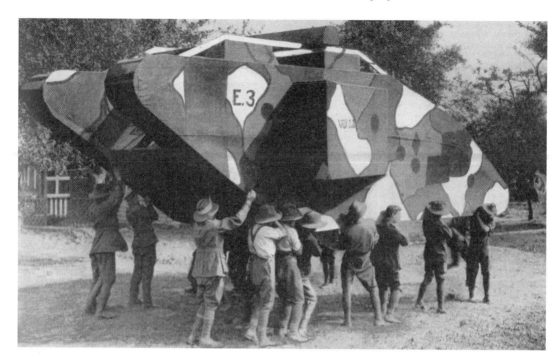

Above: A dummy tank borne aloft by men of the 4th Australian divisional engineers near Le Catelet. Similar fake tanks, some produced as rubber inflatables, were also used in the Second World War, particularly in Operation Fortitude's phantom army used to persuade the Germans that the D-Day landings would take place in the Calais area rather than Normandy. *Below:* Vickers guns have been mounted on these crudely armoured vehicles operated by a Canadian motor machine-gun section. Their mobility was an advantage in the rapid retreat of the Allies in the spring and then for their advance in the autumn.

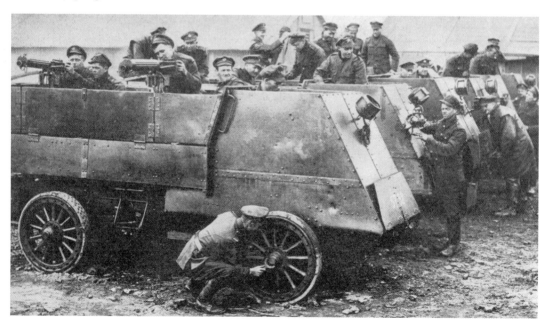

SEPTEMBER 1918

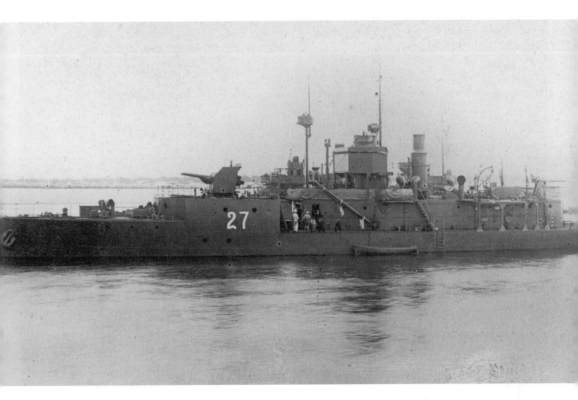

Above: The British monitor No. 27, basically a shallow-draught hull with a large gun on board, on the River Dvina. In action against the Bolsheviks, she was blown up in the retreat from Trotisa in September 1919, preventing her falling into the hands of the Bolsheviks.

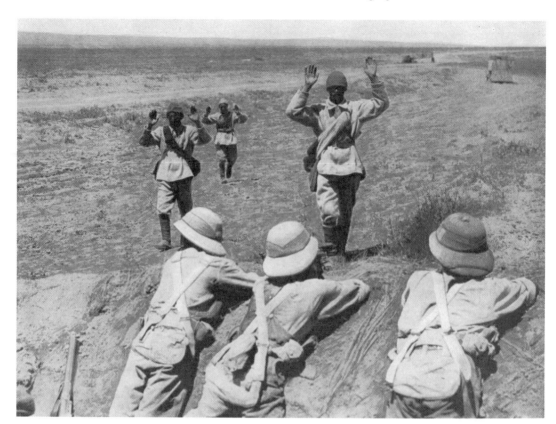

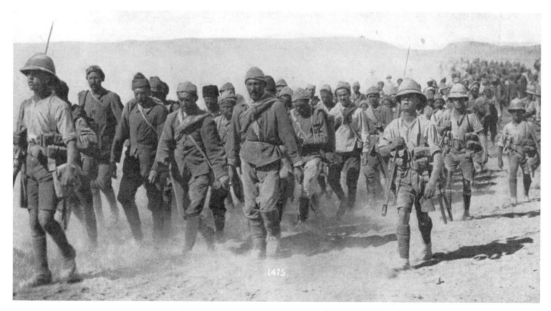

In Mesopotamia, as elsewhere, the Turks proved to be excellent fighters, although in the face of superior numbers they had become disheartened by the later stages of the war. These Turkish soldiers are surrendering after General Brooking's successful action at Ramadi in September.

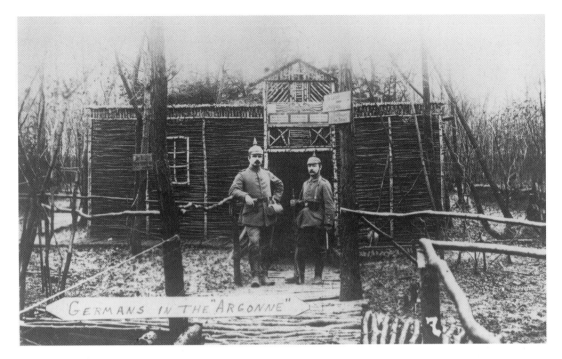

Above: 'Germans in the Argonne.' The more significant shifting of the front lines in 1918 saw the combatants often revisiting locations from earlier in the war. The Allies' Meuse-Argonne offensive was fought from 26 September 1918 until the Armistice on 11 November. *Below:* Damage to a warehouse in the Saint-Denis area of Paris caused by a German air raid on the city on 19 September 1918.

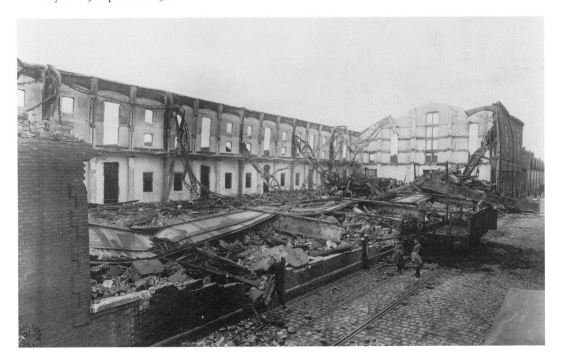

The British Mark V tanks were only seen in action towards the end of the conflict and in general they proved to be more manoeuvrable than the Mark IV. These tanks are moving forward near Bellicourt on 29 September 1918. They are carrying special fascines or 'cribs' with which to bridge the obstacles on the Hindenburg Line.

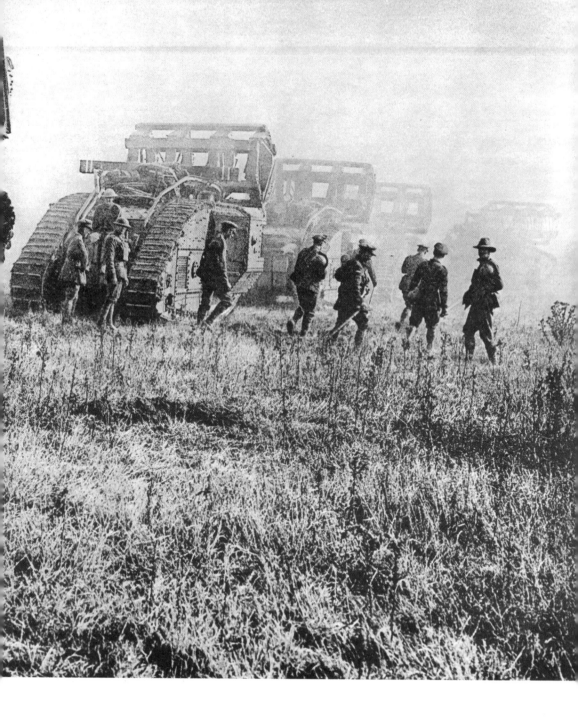

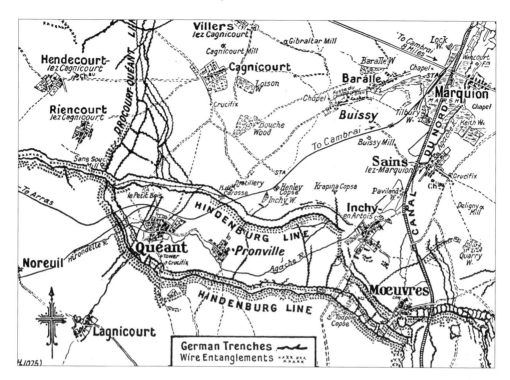

Above: The Battle of the Hindenburg Line took place from 29 September until 8 October 1918, when the German armies withdrew. *Below:* Just days after the crossing of the St Quentin Canal on 29 September, men of the 137th Staffordshire Brigade gather on the canal bank at Riqurval to listen to an address by their commanding officer, Brigadier-General J. V. Campbell.

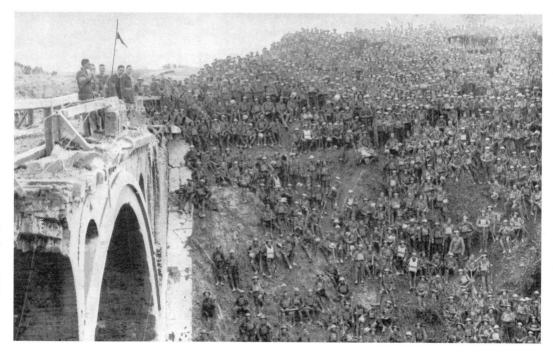

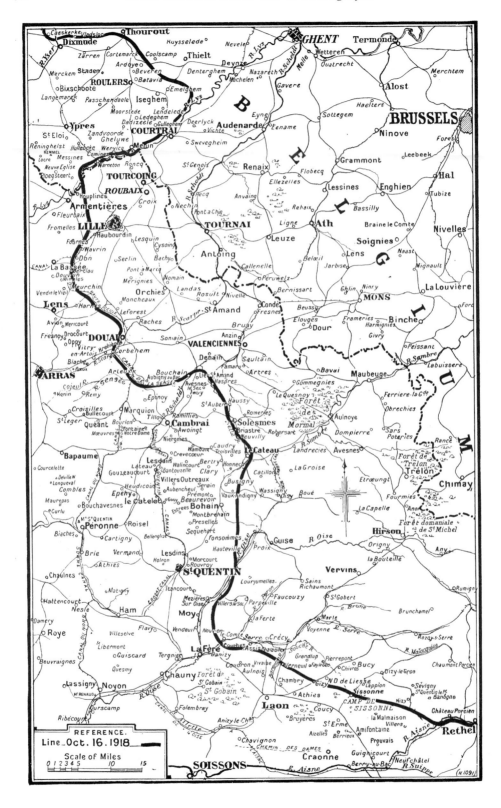

REFERENCE.
Line Oct. 16. 1918
Scale of Miles
0 1 2 3 4 5 10 15

OCTOBER 1918

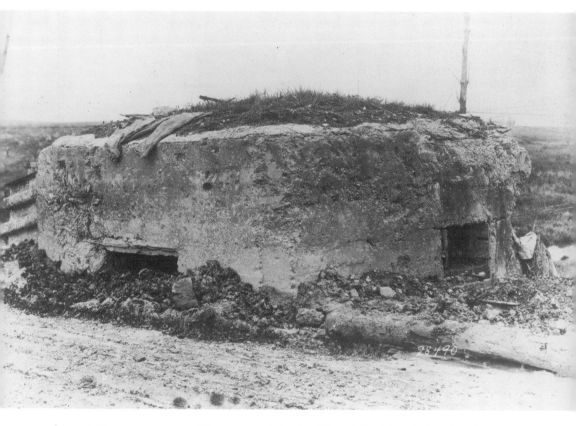

Above: A German concrete pillbox captured by the US 79th Division during the advance at Haucourt, Meuse, on 22 October 1918.

Opposite page: Map showing the position of the front line on 16 October 1918, showing the area from Dixmude in the north and down as far as Rethel.

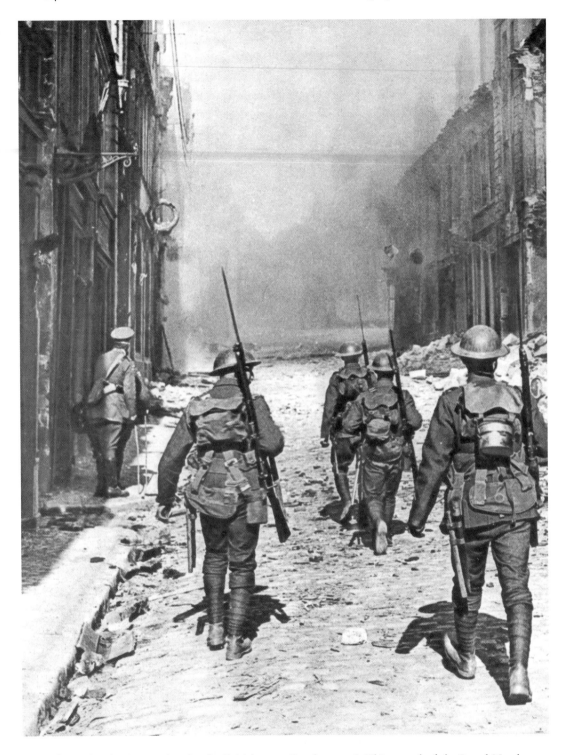

Above: Cambrai was taken by the British on 9 October 1918. This patrol of the Loyal North Lancashire Regiment is wary of explosive mines left by the retreating Germans.

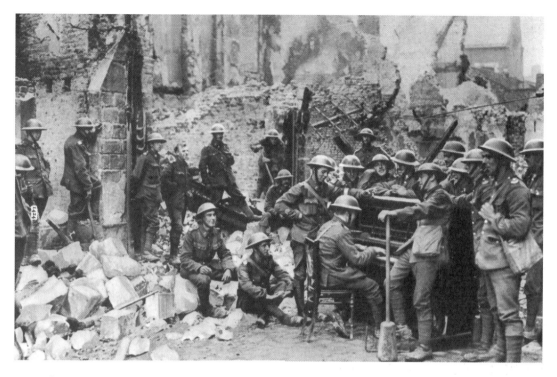

Above: Amid the ruined houses in Cambrai these troops gather around a piano for a sing-song. Most likely this scene was contrived for the official photographer. *Below:* A concrete firing step in a captured German trench in the Meuse area.

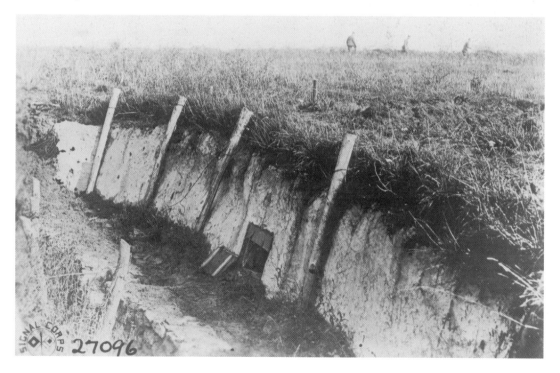

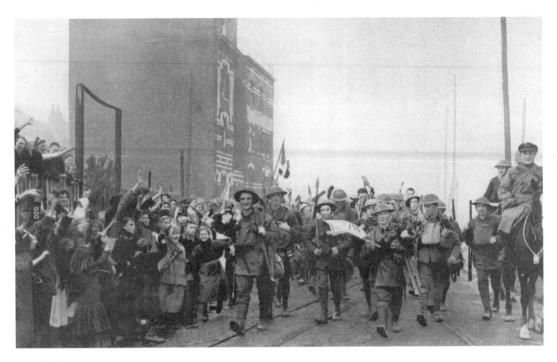

Above: Entering Lille on 17 October. A rapturous reception for the men of the Liverpool Irish, a battalion of the King's Regiment (Liverpool). *Below:* French tanks passing through Rampont on 10 October 1918. By this stage the end of the war was barely a month away.

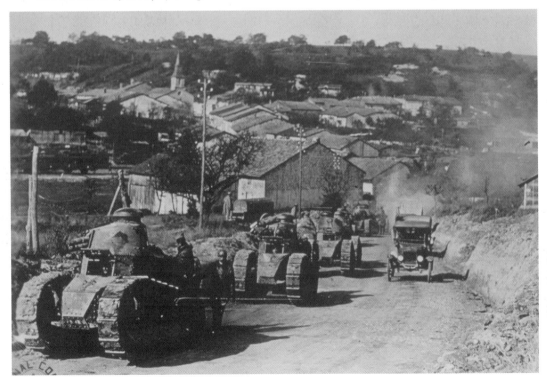

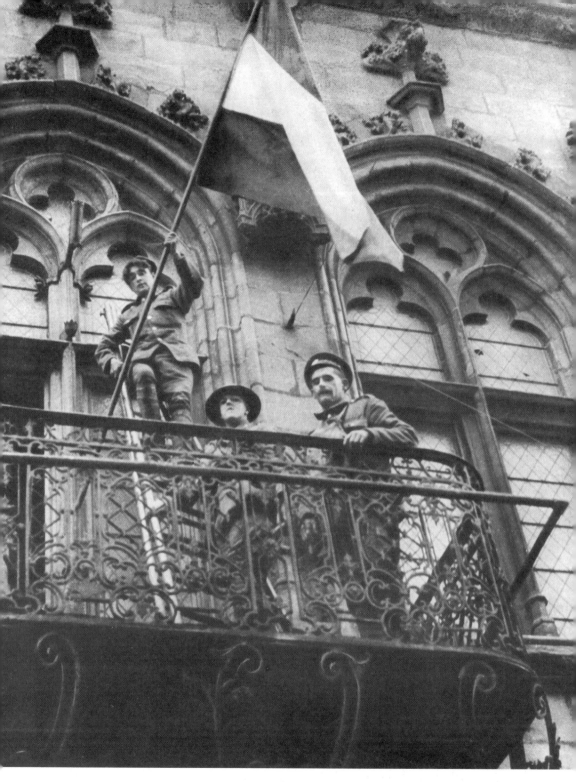

Above: A Royal Engineer takes down the despised German flag from the the balcony of the prefecture building at Douai. The town was captured by the British forces on 15 October.

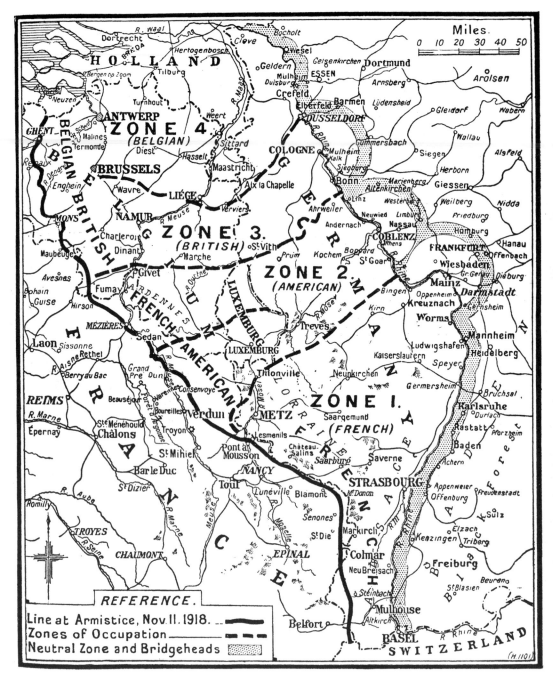

Above: The Allied Zones of Occupation under the Armistice. The position of the front on
11 November 1918 is shown by a solid line.

NOVEMBER 1918

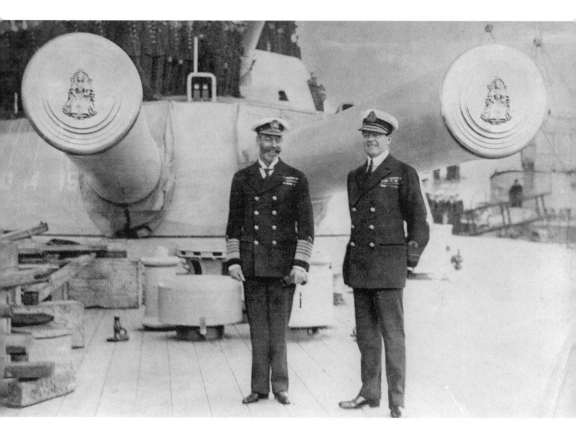

Above: King George V and Admiral Beattie on the deck of HMS *Elizabeth* before the surrender of the German fleet in November 1918.

Above: Near Maubeuge on the morning of 11 November, a British battery is firing what proved to be some of the last shots of the war. Aware of the historic nature of the moment, a film cameraman is recording events. *Below:* A house in Choisy-au-Bac in northern France, burned by the retreating Germans, November 1918.

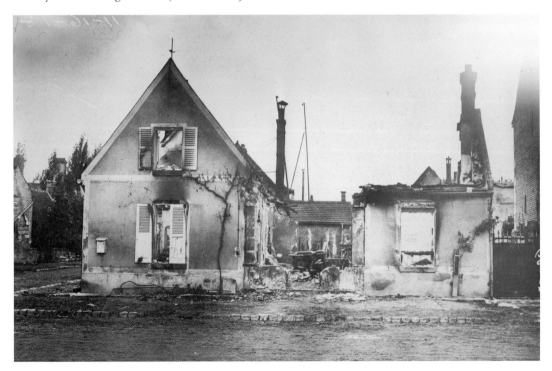

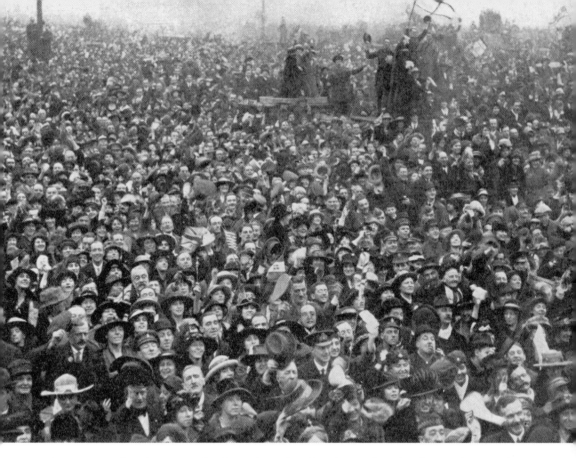

Above: In London, huge crowds of people gathered in front of Buckingham Palace on the morning of 11 November 1918 to celebrate the signing of the Armistice. *Below:* In contrast, the scene outside the Reichstag on 9 November as Philipp Scheidemann proclaims the establishment of the German republic and the end of the empire.

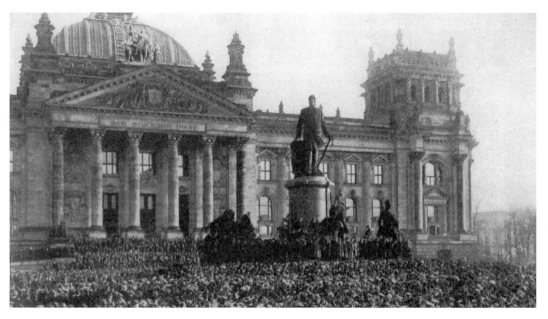

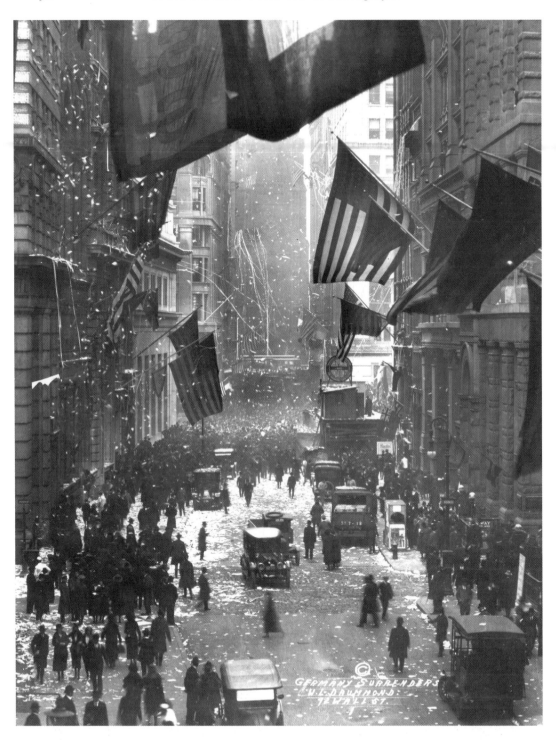

Above: Armistice celebrations in Wall Street, New York, on the announcement of Germany's surrender. Unlike the other Allied countries, in the USA 11 November became All Veterans Day – later shortened to Veterans Day – which honours those who have served in the armed forces.

The Armistice was signed on 11 November 1918 in Foch's private railway carriage at a siding in the Forest of Compiègne. From 1921 to 1927 the carriage was displayed on the Cours des Invalides in Paris, shown above. Following the German invasion in 1940, Adolf Hitler symbolically used it to accept the surrender of the French on 22 June, and it was later taken to Berlin, then Ohdruf, where it was destroyed by SS guards in early 1945.

Above: A car passes through the British lines a few days after the Armistice. The occupants are German officers carrying information on the locations of land mines.

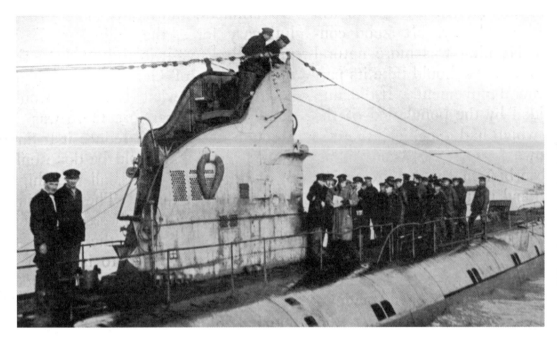

Above: Over the course of the two weeks following the Armistice, negotiations took place for the surrender of the German navy. All of the submarines were ordered to Allied ports, with the majority ending up in Harwich.

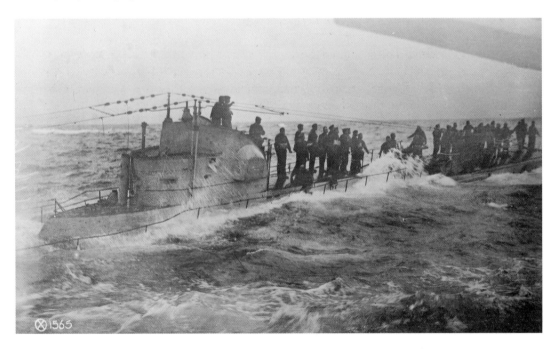

Above: On 17 November 1917 the U-58 had surrendered to the American destroyer USS *Fanning*, and this image of the German crew preparing to abandon ship formed part of an exhibition of naval photography held in Piccadilly, London, in the summer of 1918.

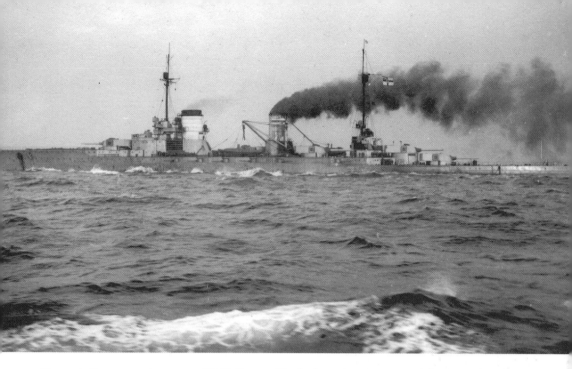

Above: A German cruiser passes HMS *Queen Elizabeth* on the afternoon of the surrender. The German fleet of some eighty vessels, including destroyers, cruisers and battleships, was ordered to the Firth of Forth, where almost 250 Allied vessels would meet them.

The Surrender and Salvage of the German Fleet

On 11 November 1918, an Armistice between the Allied forces and those of Germany, Austria-Hungary and their allies was agreed. One of the conditions was that the German High Seas fleet and their submarine force were to surrender. Over 200 submarines sailed for Allied ports within the following two weeks, while the surface fleet of around seventy-four vessels was to sail for Allied or neutral ports and be interned, their fates to be decided by the peace negotiations.

The ships were disarmed, emptied of ammunition and small arms and sailed for the Firth of Forth on 19 November. Rear Admiral Ludwig von Reuter commanded the fleet aboard *Friedrich der Grosse*. A massive fleet of around 250 Allied warships awaited the German ships on the 21st as they arrived in Scotland. All guns were trained fore and aft but there was no doubt the crews were ready for action. The German flags were hauled down at 3.57 p.m. and not raised again for seven months. Each ship was checked over and they sailed for Scapa Flow, the great Orkney anchorage, between 22 and 26 November. In rows, they remained at Scapa. Admiral of the Fleet Sir David Beatty took the surrender from Admiral Meurer, who had been brought to HMS *Queen Elizabeth* on the diminutive destroyer HMS *Oak*. Meurer had been captain of the SMS *Deutschland* at Jutland in 1916, and was promoted to Rear-Admiral in 1917. He commanded the German intervention in the Finnish Civil War before negotiating the terms of the surrender of the fleet.

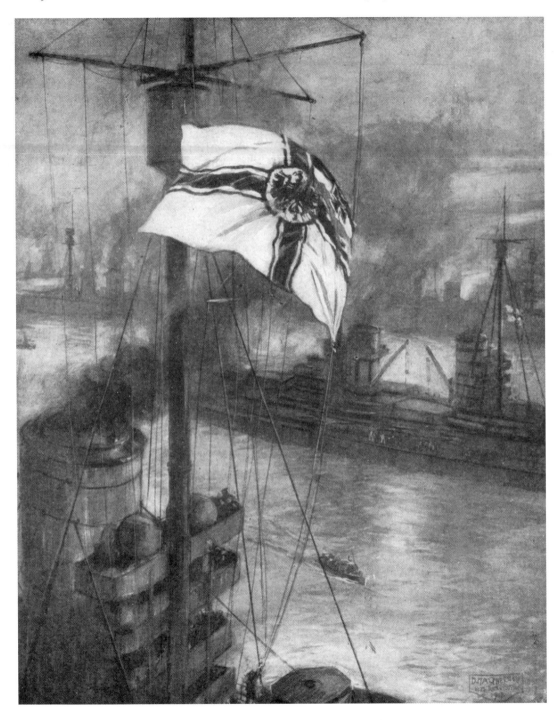

Above: Drawn by Douglas MacPherson, on board HMS *Resolution*, the German sailors lower the Imperial battle flag on one of the battleships at sunset on 21 November 1918. Despite the German ships still belonging to Germany, Admiral David Beatty insisted they could no longer fly their ensigns, technically a breach of maritime law.

TO BE COMPLETED IN FIFTY-SIX WEEKLY PARTS

Part 40
SEVENPENCE

WORLD WAR
1914-1918 A PICTURED HISTORY

SIR JOHN
HAMMERTON
Editor

The cover of a part-work account of the war published in Britain. These men have suffered an attack of lachrymatory 'tear' gas, consisting of a mixture of chlorine and phosgene, during the German Lys offensive. In most cases the effects, although unpleasant, were temporary but it could take several months for a full recovery.

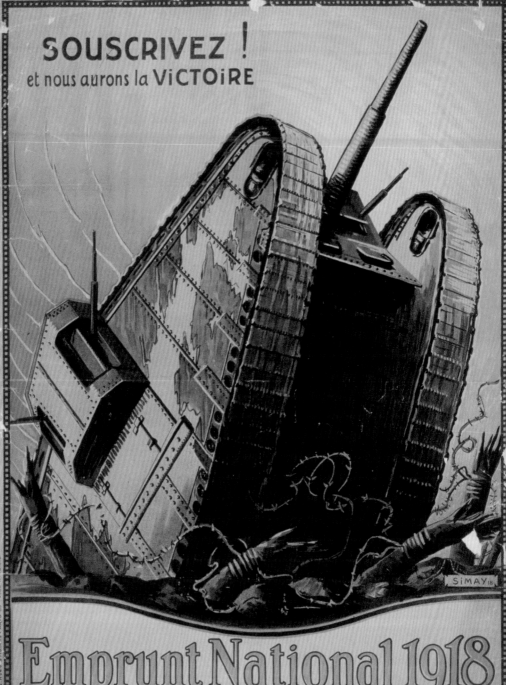

Opposite page: A French poster promoting the 1918 national savings scheme, and featuring a dramatic depiction of a British tank.

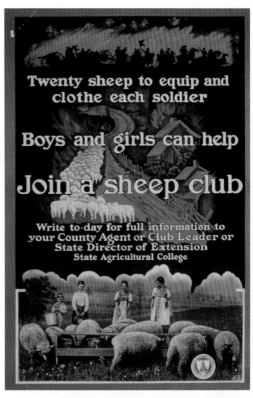

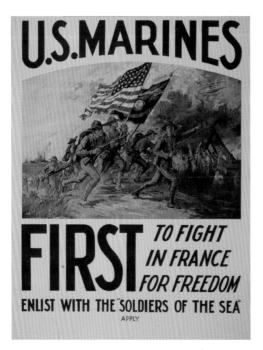

Above: 'First to Fight in France for Freedom' – poster for the US Marines.

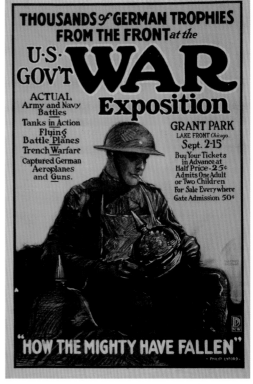

Right: Two more wartime posters from the USA. The Sheep Club to equip and clothe the soldiers, top, and at the bottom a poster for captured German equipment being put on display at Grant Park in Chicago. Although the poster shows leather Picklehaube spiked helmets, the exposition was a major event and included tanks, guns and aircraft. The 'actual army and naval battles' sound intriguing.

Was England will!

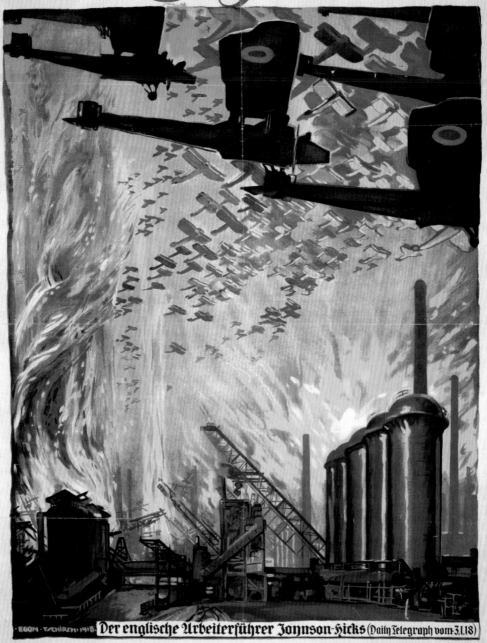

EGON · TSCHIRCH · 1918 · Der englische Arbeiterführer Joynson-Hicks (Daily Telegraph vom 3.1.18)

„Man muss die rheinischen Industriegebiete mit hundert Flugzeugen
Tag für Tag bombardieren, bis die Kur angeschlagen hat!"

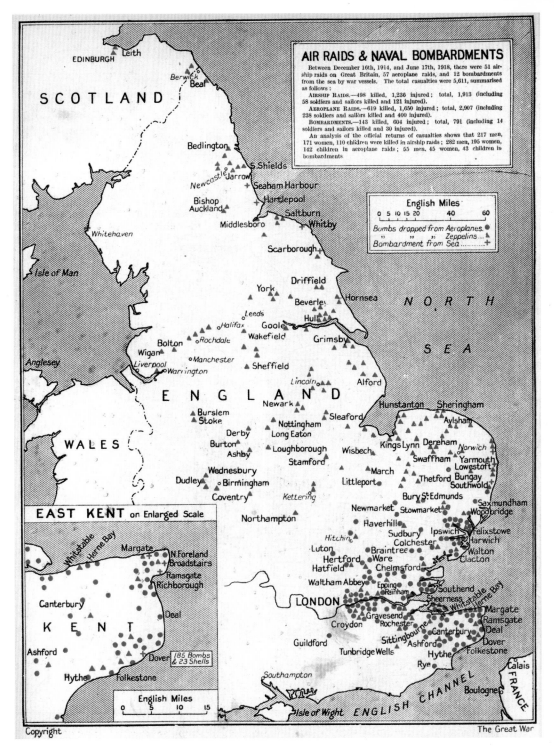

Opposite page: 'Was England Will!' (What England Wants!) A German poster portraying fleets of British bombers pounding industrial targets. *Above:* A chart showing the locations of air raids and naval bombardments between December 1914 and June 1918.

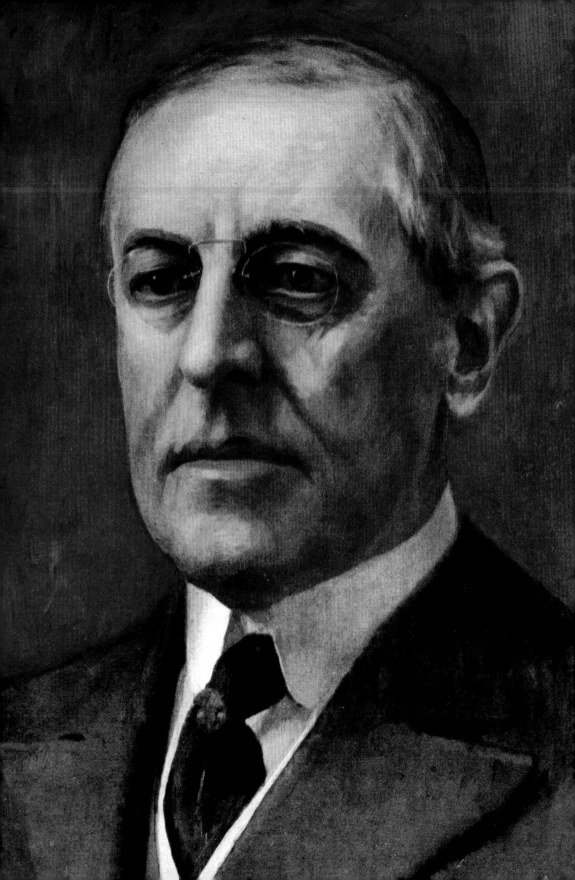

Right: In December 1916, the War Minister David Lloyd George succeeded Herbert Henry Asquith as Britain's Prime Minister and remained in the post until October 1922. Despite many difficult issues throughout the last year of the war, in particular proposed measures for conscripting more men to counter the Germans' Spring Offensive, Lloyd George remained an enormously popular figure with the public. In December 1918 he led a coalition of Conservatives and Liberals to a landslide victory at the General Election. Lloyd George had introduced a programme of social reforms in the last months of the war, including the Representation of the People Act 1918 which gave the vote to women over thirty. He was one of the millions of British people infected in the great flu epidemic of 1918, but survived and he died in 1945.

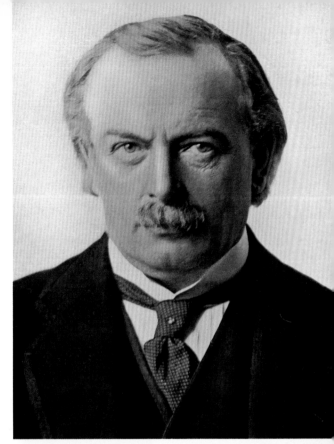

Bottom right: Georges Clemenceau was the French Premier from 1906 to 1909 and again from 1917 until 1920. He was one of the major architects of the Treaty of Versailles and his harsh stance against the defeated Germans earned him the popular nickname of 'Père la Victoire' (Father Victory).

Opposite page: Woodrow Wilson was the US President from March 1913 until 1921. At the outbreak of the war Wilson had maintained a stance of neutrality, but the continued action of U-boats against American vessels saw a shift with the US lending money and equipment to the Allies and finally, in April 1917, an all out declaration of war against Germany.

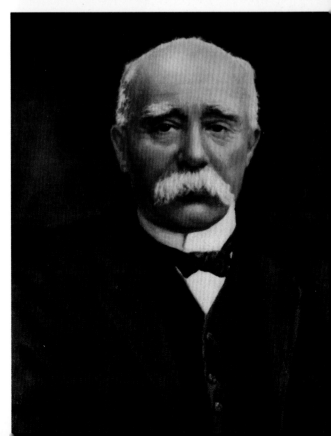

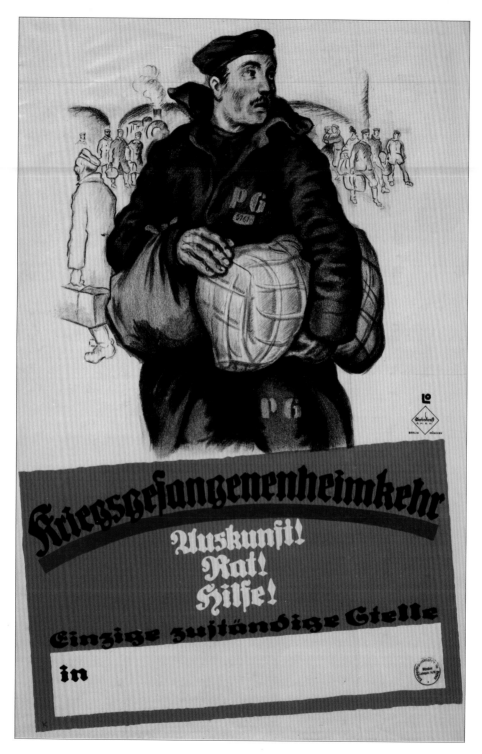

Above: 'Kriegsgefangenenheimkehr' (War Prisoners Homecoming), a German poster published in 1919 with information to be added on the location of advice centres to help the returning POWs. *Opposite page:* Typical US propaganda poster from the later war years.

Defeat the
KAISER *and*
his **U-BOATS**
Victory Depends *on*
Which fails first,
food *or* frightfulness

Waste Nothing

UNITED STATES FOOD ADMINISTRATION

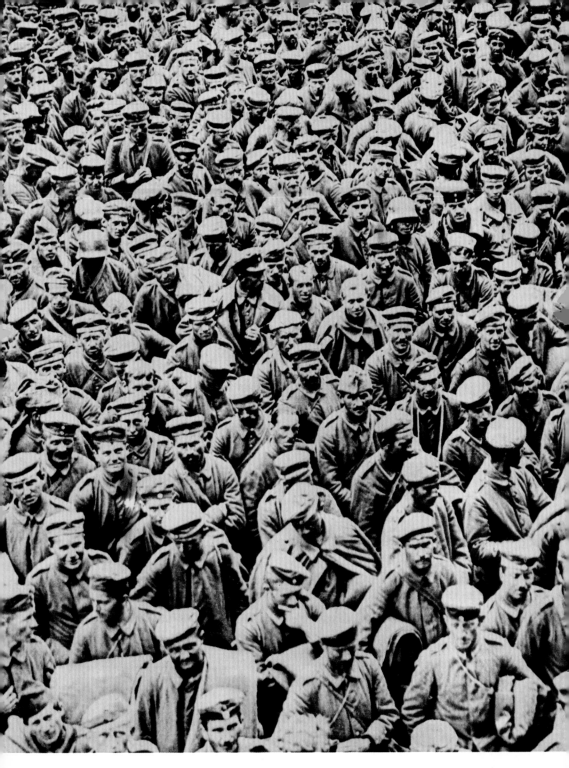

This sea of faces of German prisoners reflects mixed emotions with relief that the fighting is over and, for many, anxiety about the future. The original caption states, 'The tide has turned. This huge crowd of German prisoners near Abbevale, on 27 August 1918, bears striking witness to the British successes on the Somme battlefields.'

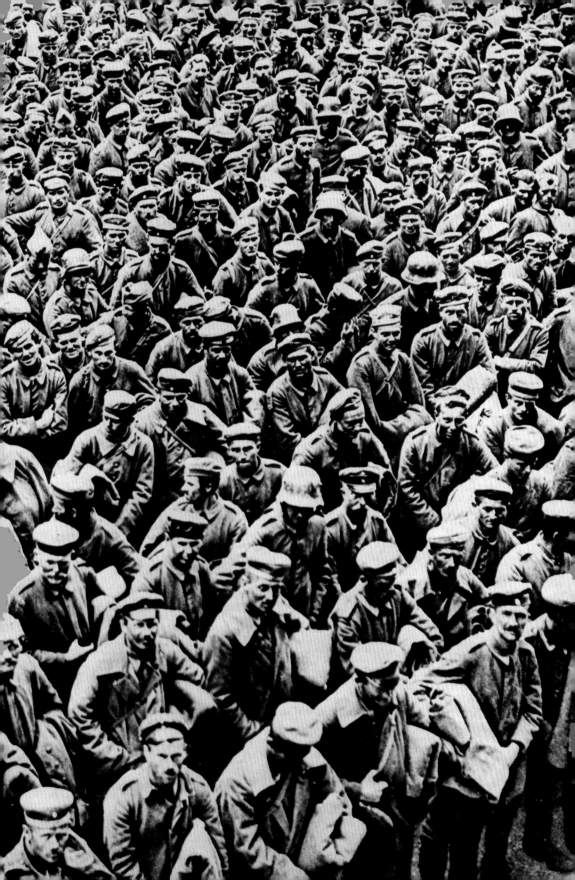

Shay Alf, old man, you're gone quite bald!— you're worrying too mush about thish war, y'know!

Opposite page: An illustration depicting some of the roles carried out by members of the Women's Army Auxiliary Corps, a voluntary service established by the British government in January 1917. Although not a military organisation as such, many of the women served in France providing support for the men at the front. However, there were some suggestions in the popular press that some of them were sent home because they were becoming too 'friendly' with the soldiers.

When's the war going to end, dad? I don't know, lad, ask your mother!

Two wartime Bamford comic postcards from the Home Front. 'Shay Alf, old man...' is No. 695, shown above, and 'When's the war going to end...', No. 700, is on the right.

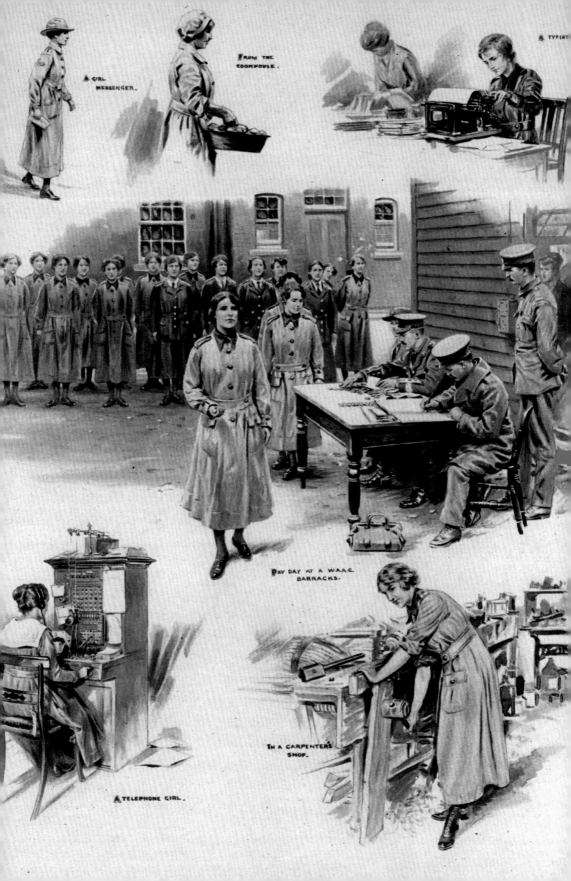

A GIRL MESSENGER.

FROM THE COOKHOUSE.

A TYPIST.

PAY DAY AT A W.A.A.C. BARRACKS.

A TELEPHONE GIRL.

IN A CARPENTER'S SHOP.

Learning to Walk for the Second Time

After some practice these leg-less men walk as well as unin-jured persons. The French soldier on the right has been fitted temporarily so that he can get about soon after his operation. The peg leg is worn while the stump is assuming final shape and the more elab-orate limb is being made.

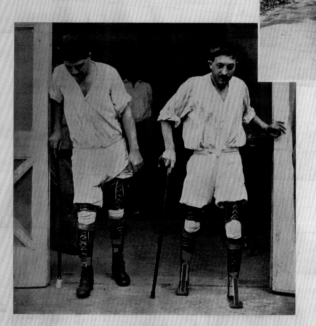

These Italian soldiers, in a school at Naples, are being taught to walk on their new legs.

Information on the rehabilitation of the wounded, published in 1919 by the Red Cross Institute for Crippled and Disabled Men.

Exhibit of the
Red Cross Institute for Crippled and Disabled Men
and the
Red Cross Institute for the Blind

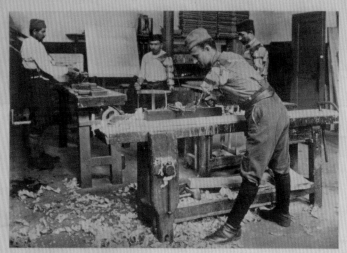

Disabled Serbians Working in the
Carpentry Shop at Lyons, France

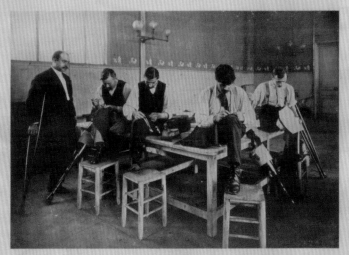

A Tailoring Class in Paris Taught
by a One-legged Instructor

In France, Two Popular Trades Taught Disabled Soldiers Are Cabinet-making and Tailoring

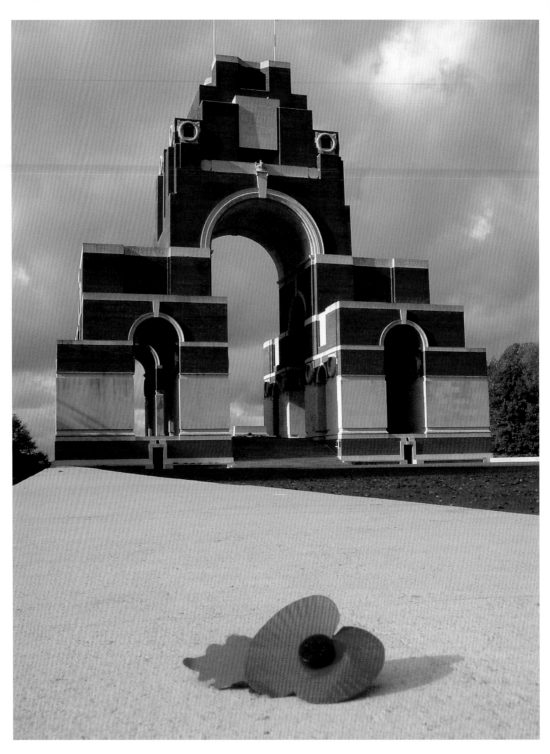

Lest we forget. The Thiepval Memorial to the Missing of the Somme – the 72,195 British and South African men with no known grave. Designed by Sir Edwin Lutyens, the great arch in Picady, France, was built between 1928 and 1932.

The British, French and American fleet that awaited the Germans was prepared for action and many of the sailors wore their blast protection just in case. As it turned out, the surrender was peaceful and the subdued Germans sailed in groups from the North Sea to captivity at Scapa Flow.

Once the ships had all arrived at Scapa Flow many of the crews were repatriated, but those that remained kept the ships maintained, with the odd letter from home to occupy their time as they were confined to the ships.

It was a lonely life for the German sailors. Confined to their ships, with only the occasional letter for comfort, they endured an Orcadian winter and spring. As summer approached, the Peace terms were being thrashed out. What would happen to the German navy? One thing was sure: the ships were not being returned to Germany and they would be split between the Allies. Despite the possibility of gaining a sizable number of new ships, the arrangement did not suit the British. The French and Americans would acquire many new vessels and the balance of power worldwide would change. For the defeated Germans, handing over the vessels would mean they would never be able to catch up in any naval arms race again.

Von Reuter had already decided that the fleet should be scuttled and began his preparations, knowing the fleet was to be seized as soon as the Peace Treaty was

Below: Filmed for posterity as members of the press watch, and with flags still fluttering from the aft mast, one of the German battleships at the surrender. It was a momentous occasion, and one of the largest gatherings of naval vessels at sea until the Allied invasion of North Africa in 1942.

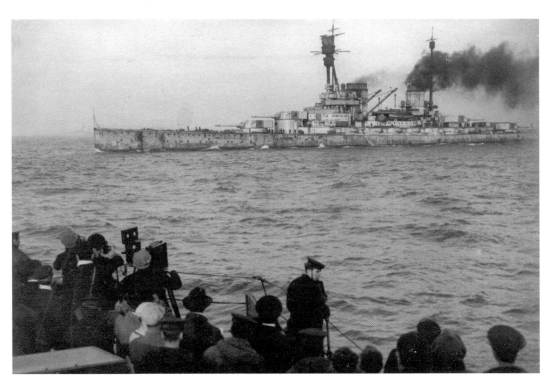

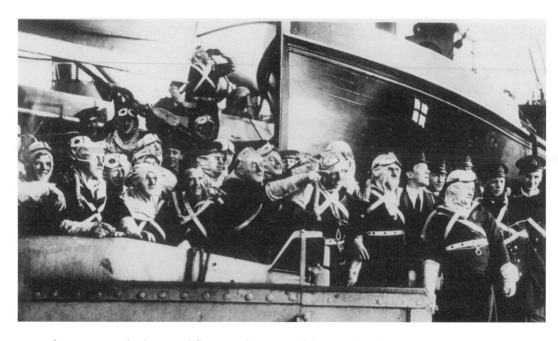

Above: Wearing both gas and flame masks, many of the British sailors mistrusted the Germans and expect them to come out fighting. All guns were trained on the German ships, which had had their armaments removed before setting sail.

signed on 23 June. In secrecy, he planned the operation with his senior officers. A secret code word was issued and the instructions were that sea cocks were to be opened, torpedo tube valves and other openings damaged in such a way that they could not be closed. On 20 June, a signal using flags was seen on *Emden*'s peak and it was answered by the other ships of the interned fleet. Next day the British First Battle Squadron exited Scapa on an exercise. Only one destroyer, a few drifters and trawlers and a solitary depot ship were left to guard the ships. Two other destroyers were being repaired also. Soon the German fleet was flying the signal again, which translated as 'Paragraph 11, Confirm', the code for 'sink all ships immediately'. It would be the beginning of the end of the naval arms race that had led to war. For the Germans it would be a blessing as they would finally escape the damp, cold Orkneys and be repatriated back to Germany.

With the results of the Peace terms almost announced, the German commanders decided their ships would not be used as pawns in the international negotiations. It suited Britain that the ships would not head off elsewhere to change yet again the balance of naval power. The day chosen by the Germans for the sinking of their fleet was also the day the British navy sailed from Scapa on an exercise. Whether this was deliberate or a happy coincidence, it left the German sailors to their own devices and with the ability to ensure the ships would be gone by the time the British fleet returned.

The first signs of action began at about 11.45 a.m. as sailors from the *Friedrich der Grosse* began to throw their belongings into rowing boats. *Frankfurt*'s sailors

were doing the same. It was obvious the ships were beginning to sink and a message was sent to the Battle Fleet to return to Scapa, as the trawler *Sochosin* went to the *Frankfurt* to find out what was happening. Soon, many of the fleet were slipping under the waters of Scapa. However, the depot ship *Sandhurst* and numerous trawlers and drifters managed to beach eleven destroyers, while the battleship *Baden* and two cruisers lay in shallow water in Swinbister Bay, with another light cruiser off Cava. A group of Orcadian schoolchildren, aboard the *Flying Kestrel*, were on a trip round the fleet and were caught in the action as the ships went down around them.

Men from the *Westcott* managed to board the *Hindenburg* but water was sloshing around inside and it was soon obvious it was getting deeper and deeper. Explosives were used to break her anchor chain and she started to drift to shore. She was soon under tow but once in shallow water she beached and turned turtle. From the *Hindenburg*, *Westcott* went to the *Nürnberg* to try to save her, slipped her anchor and watched her drift ashore.

By 2.30 p.m., the first destroyers had returned to find only two battleships, one battle cruiser and four light cruisers still afloat, with the once neat lines of warships nowhere to be seen, with some beached or upside down in the shallow water. While the few ships were still afloat, they were sinking too. The day after, only *Baden*, three cruisers and eighteen destroyers were above the waters of Scapa. The rest of the fleet would no longer pose a menace to Allied shipping, nor would it be of use to the Allies and Britain remained the supreme naval power in the Atlantic.

The Admiralty decided that the ships could not be salvaged and that, as most posed no threat to navigation, they would remain in Scapa Flow. By the mid-1920s, it was obvious the ships were a danger to shipping, both naval and the many trawlers in the vicinity. The glut of wartime scrap had already been used up too and there was a demand for quality steel scrap for the steel furnaces of the world. Some enterprising Orcadian farmers and fishermen had already relieved the more accessible vessels of any easily recovered non-ferrous scrap but there still remained hundreds of thousands of tons of high quality metal in Scapa.

The first ship, a destroyer, was recovered in 1922 by the Stromness Salvage Syndicate and cut up in Stromness. Novel uses were found for the boiler tubes, which, when polished up, became curtain rods. In June 1923 a new syndicate bought some of the vessels and began work to recover them using concrete barges. The barges were connected with girders and chains placed around the destroyers. Slowly, they would be lifted clear of the bottom. Another man intent on salvage was Ernest Frank Guelph Cox. He visited the area and looked at the vessels, announcing he had bought over twenty vessels, including *Hindenburg* and *Seydlitz*. Salvage operations would begin on these vessels quite quickly and Cox used the naval base at Lyness, from where operations could be controlled. Cox, from Dudley, had made his money during the war, when his factory made shell cases. He had started shipbreaking in 1921 with the purchase of HMS *Orion* and *Erin*, which he broke up in Queensborough. In the yard was a German floating dock, with a pressure-testing cylinder for submarines, and with a lift of 3,000 tons.

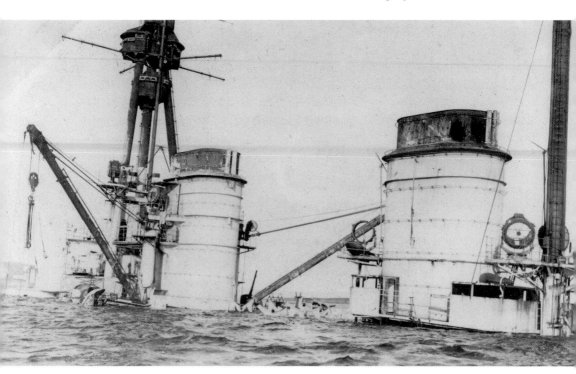

The German ships were scuttled at Scapa Flow in June 1919, a day before the Armistice terms became a peace settlement. Above is SMS *Hindenburg*, which would be the trickiest of all the German ships to salvage, despite her lying in shallow water, upright, with her superstructure above the water. *Below:* British sailors atop the overturned hull of another German battleship. Despite being declared safe and not a hazard to shipping, by the early 1920s it was obvious that the ships were a danger and their salavage began.

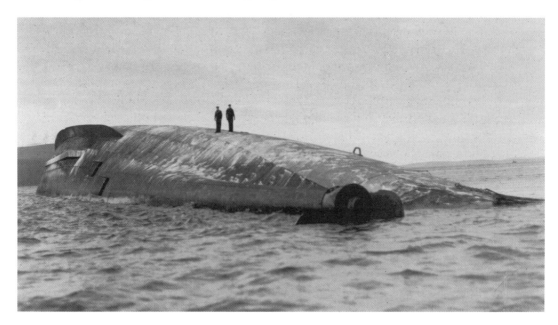

The tube was sold and the dock transported to Lyness. Two tugs, the *Ferrodanks* and *Sidonian*, were also bought off the Admiralty. When it arrived at Lyness, one side of the dock was cut away so that it created a floating platform that could be used to salvage the ships.

The small destroyers were the first ships to be recovered. Most were in shallower water and they could be salvaged with ease. The first, V70, was of 924 tons and lay in less than 50 feet of water a mere half mile from Lyness. The dry dock was berthed beside the V70 and lifting began. The principle would be that V70 would be lifted on each tide about ten feet and transported to shallower water until she was ashore. Unfortunately, there was an issue with the chains used to lift her and she had to be placed back into the water again and new 9-inch-thick hawsers replaced the 3-inch chains. On 31 July 1924 another attempt was made to lift V70. This one was successful and after four lifts she was ashore. The price of scrap had fallen so V70 was made watertight and renamed *Salvage Unit No.3*.

With two salvage teams working in Scapa Flow, competition between them was fierce. However, Cox & Danks were more successful, raising their third destroyer on 29 August 1924, the same day as Robertson's syndicate raised its first. By 13 November, Robertson had raised three destroyers and Cox a few more. During the winter of 1924/25, Robertson suffered damage to his concrete barges and after a fourth ship had been raised he gave up on salvage. Within twenty months, twenty-four ships had been raised, with one, S65, being lifted in four days. The Germans had done their work correctly when the ships were scuttled, with major damage to sea cocks, all watertight doors opened, portholes left open, all valves open or damaged and even the toilet plumbing damaged. Some of the vessels salvaged were transported to Rosyth for breaking while others were cut up on site.

As work slowed on the destroyers, the locations of the capital ships were marked and preparations began for their salvage too. *Hindenburg* was upright in 70 feet of water. She had been built between 1913 and 1917 and had not seen action at Jutland. The salvage effort on the battleships and cruisers was more tricky and each would be raised by sending divers in to the wrecks to close and seal any openings, then compressed air would be pumped in to give the ships buoyancy, from which they should rise out of the water and be towed away for scrapping. As she was being salvaged during an Orcadian gale, destroyer G38 was blown against the floating dock, which was damaged, causing *Hindenburg* to be completely flooded once more. Partially raised by late August, she was free of the bottom in September but another gale saw the pumps damaged and *Hindenburg* back underwater, after £30,000 had been spent raising her so far. Next to be salvaged was *Moltke*, actually upside down but above water most of the time. Holes were sealed and compressed air pumped into the hull. Using huge air locks, the men could enter a ship even when sunken and this process became the way of salvaging the big capital ships. Inside the ships, even underwater, the men could work in an environment of compressed air, patching holes, closing valves, hatches and portholes. By June 1927, *Moltke* was afloat and was towed to Lyness, before being readied for the tow to Rosyth, where she would be cut up. In May 1928, the weather was deemed good enough to

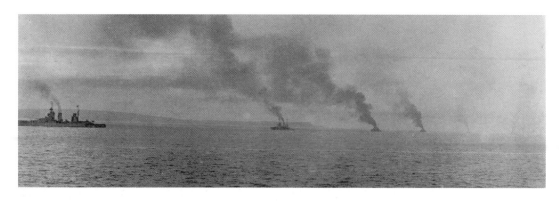

Above: HMS *Lion* leading a group of cruisers into Scapa Flow. The German fleet was searched, and checked for contraband and any form of weapons or ammunition and then the ships were led to Scapa in groups of five or so for internment.

risk the tow. *Moltke* reached Rosyth despite a perilous journey and was scrapped in the dry dock there.

Between 1930 and 1939, a large number of vessels were lifted and broken for scrap, the last being *Derfflinger*, which was raised in July 1939 and generated 20,000 tons of scrap. *Prinz Regent Luitpold* was the last ship raised by Cox, the salvage work being taken over in 1933 by Metal Industries Ltd. They had soon purchased *Baden* and *Bayern* from the Admiralty, with *Grosser Kurfürst* costing them £2,000 to buy. *Friedrich der Grosse* grossed £134,886 in scrap so the purchase expense was minimal in terms of the real cost of raising one of the vessels. It was not only the war which saw operations cease but that most of the easily accessible ships had been raised. The feat of raising the others was too great and the depths too deep to justify the expense and danger of salvage. Remaining in Scapa are the *Dresden, Kronprinz Wilhelm, Markgraf, Koenig, Cöln, Karlsruhe* and *Brummer* as well as the destroyer V83, which was raised, then used during the salvage work and subsequently abandoned.

As well as the scuttled German ships, Scapa is also home to the *Royal Oak*, sunk in 1939 by a daring U-boat captain called Güner Prien. She is now a registered war grave and dives are not allowed on her. The First World War HMS *Vanguard*, blown up at anchor, remains too as a war grave. However, a large tourist industry has grown up around the German fleet and the blockships placed in Scapa to prevent another U-boat attack. Occasionally, some metal is still salvaged from the German vessels due to the non-radioactive metal found aboard them. Post-1945, the world had changed and all metals produced subsequently have had a slight radioactive trace, and the metals from the sunken navy have proved invaluable in sensitive measuring equipment. Today, the raising of the ships at Scapa has proved to be one of the most interesting salvage attempts of all time, with over sixty vessels beached or salvaged in the twenty years from the sinking until the start of the Second World War. Eight still remain, mainly capital ships, forming the sunken navy of Scapa Flow.

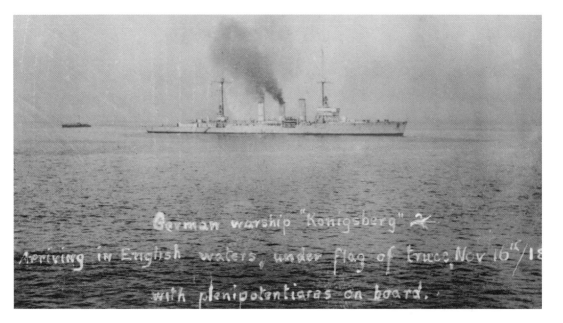

German warship "Königsberg" ✗
Arriving in English waters, under flag of truce, Nov 16ᵗʰ/18 with plenipotentiaras on board.

Above: The *Königsberg* arrives in British waters to negotiate the terms of the surrender of the German High Seas Fleet. Rear-Admiral Meurer boarded the *Queen Elizabeth* for the surrender negotiations. Admiral Beatty would take the opportunity to humiliate the Germans and referred to Meurer as a 'wretch' throughout the negotiations.

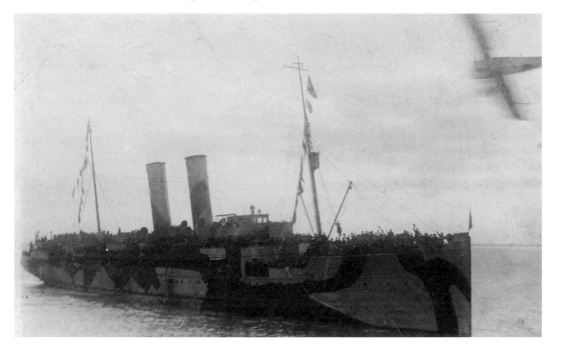

Above: HMS *Archangel* loaded with POWs in November 1918. This Great Eastern Railway steamer, shown here in camouflage, was used as a troopship and in 1918 brought many British POWs back to Hull.

The scars of war left an indelible mark on the landscape, and to this day shells and even human remains are still being found by the farmers working the land. *Top:* 'No-mans land, once a forest in Flanders fields.' *Bottom:* The blasted ruins of Forges-les-Eaux, a town in northern France.

DECEMBER 1918

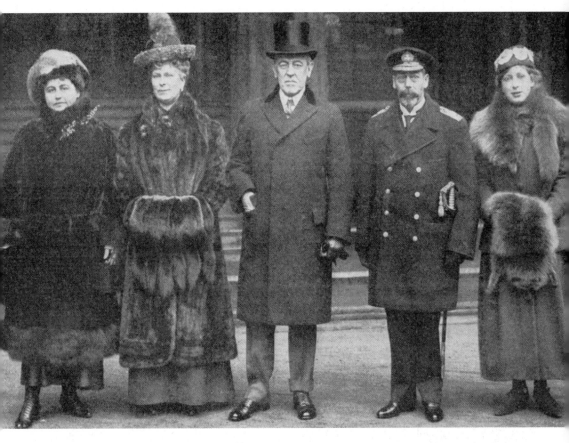

In December 1918 the US President, Woodrow Wilson, spent five days in London and attended a dinner-party held at Buckingham Palace in his honour. Shown shortly before taking the boat train from Victoria, from left to right: Mrs Wilson, the Queen, President Wilson, the King and Princess Mary.

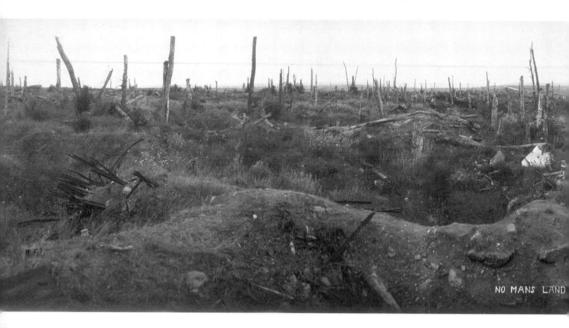

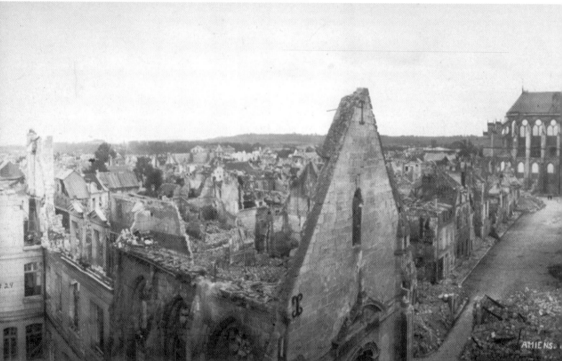

The scenes of desolation were of great interest to the public after the end of the fighting and these panoramic views from 1919 were reproduced in the USA courtesy of the Military Intelligence Division of the General Staff, US Army. *Top:* Shattered tree stumps are all that remain of woodland in what became No Man's Land in Flanders Field, France. *Bottom:* The Battle of Amiens, which began on 8 August 1918 (and would continue right up to the Armistice),

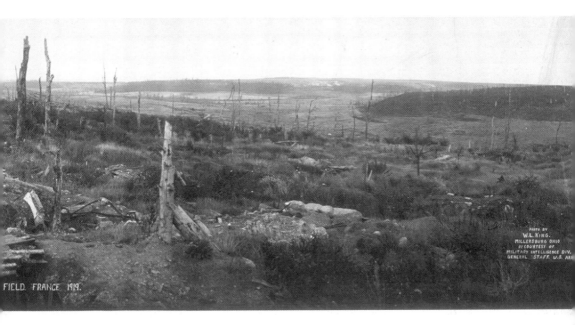

FIELD. FRANCE 1919.

PHOTO BY
W.L. KING.
MILLERSBURG OHIO
BY COURTESY OF
MILITARY INTELLIGENCE DIV.
GENERAL STAFF, U.S. ARMY

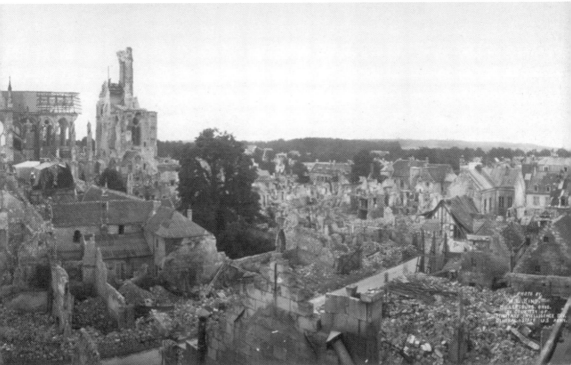

a major turning point in the course of the war. Also known as the Third Battle of Picardy, after the region within the Somme valley, it marked the start of the Allies' Hundred Days Offensive. This was the end of trench warfare and saw a return to a more mobile battlefront, ending the German thrust towards the sea and ultimately leading to the end of the war itself in November 1918.

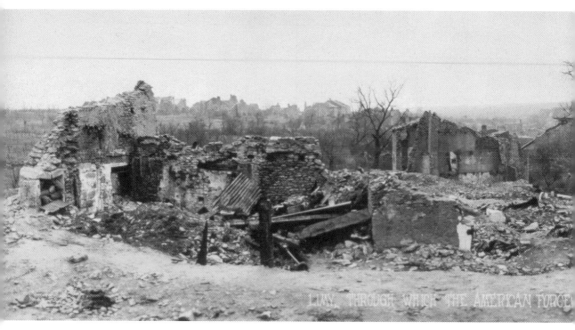

Three more panoramic views from 1919. *Top:* 'Limy, through which the American forces passed in cutting off the St Mihiel Salient, 1918.' *Middle:* 'The ruins of Montfaucon from a German observation position, captured by the American army, 27 Sept, 1918.'

Opposite: 'Former German camp between St Mihiel and Apermont, remodelled by American engineers.' The Battle of Saint-Mihiel was fought between 12 and 15 September 1918 and involved American and French forces under the command of General Pershing. With the infantry supported by tanks, it was a bold bid to break through the German lines and capture the city of Metz. The battle is said to mark the Americans' first use of the term 'D-Day', which came to such prominence in the Second World War.

IN CUTTING OFF THE

POSITION, CAPTURED BY THE AMERICAN ARMY, SEPT 27, 1918.

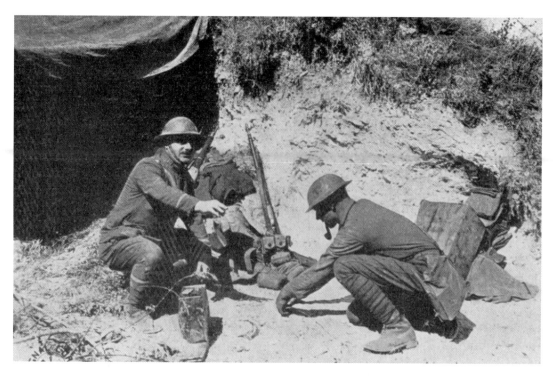

Land and sea mines were an unwelcome legacy of the war that had to be dealt with. *Above:* British engineers prepare to explode a mine left as a trap by the enemy. *Below:* Minesweeping at sea continued long after the war was over. This view gives an idea of just how dangerous minesweeping could be. Many ships lost a bow or stern or were sunk while minesweeping.

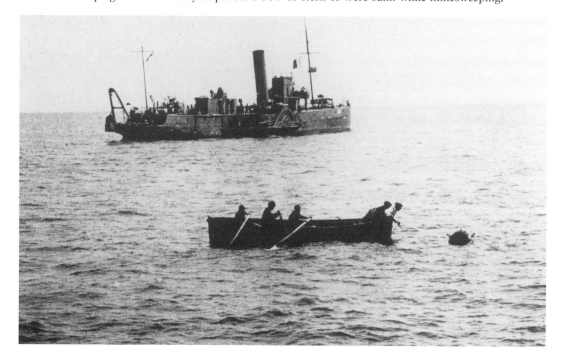

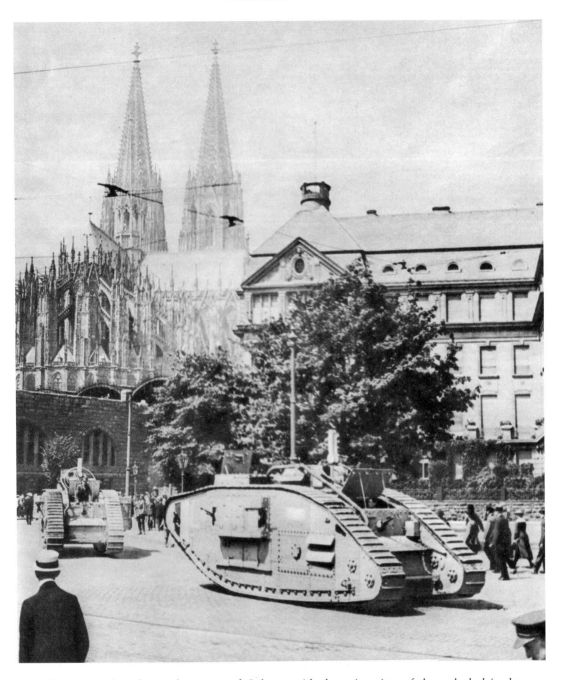

Above: British tanks on the streets of Cologne with the twin spires of the cathedral in the background. They were part of the Allied forces that had arrived on 7 December to occupy the city.

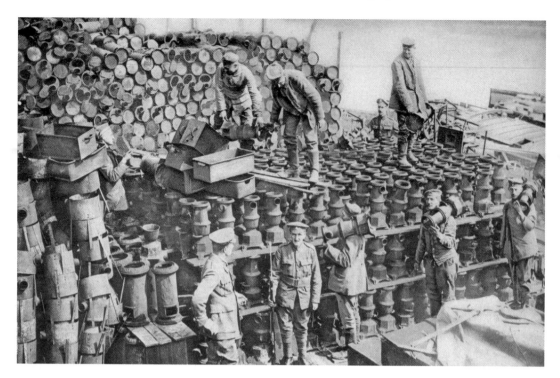

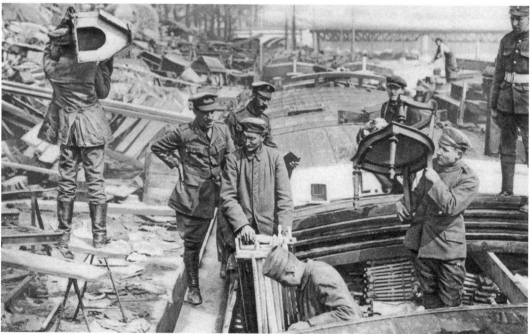

At the cessation of hostilities huge quantities of munitions and equipment of all sorts was left scattered about the front and in the stores behind it. *Top:* Under armed guard, prisoners are stacking German trench stoves at Namur in southern Belgium. *Bottom:* Unloading a barge stuffed with everything from furniture to what looks like a bird house.

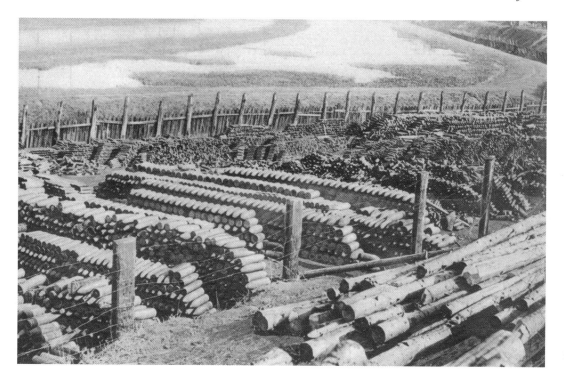

Above: Gas shells stacked in the open at Luttre, Belgium. In many cases the retreating German forces had deliberately destroyed such stores of munitions. *Below:* Again in Belgium, German prisoners load a barge with machinery.

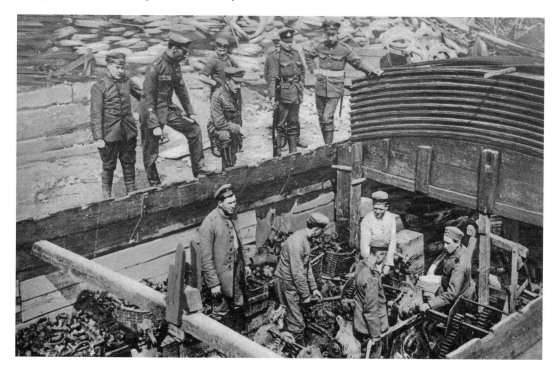

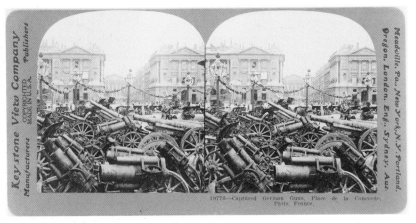

War trophies – several images of captured German guns. *Above:* This pair of field guns is being transported on an Atlantic Coast Line railway flatbed within the USA.

Middle left: A mass of guns on display in the Place de la Concorde in Paris.

Bottom left: Part of the haul of guns, including machine guns, morters and field pieces, taken by the Canadians during the advance on Cambrai.

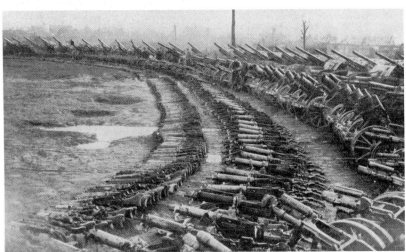

Top right: For them the war was indeed over. Some of the crew of HMS *Champion* on Christmas Day, 1918. Built by Hawthorn, Leslie on the Tyne, *Champion* was commissioned on 20 December 1915. She saw action at the Battle of Jutland and was sold for scrap on 28 July 1934 and broken up next to some of the German battleships she had spent so long at war against.

Right: The armourer's staff of HMS *Calliope* pose for a Christmas photograph, 1918.

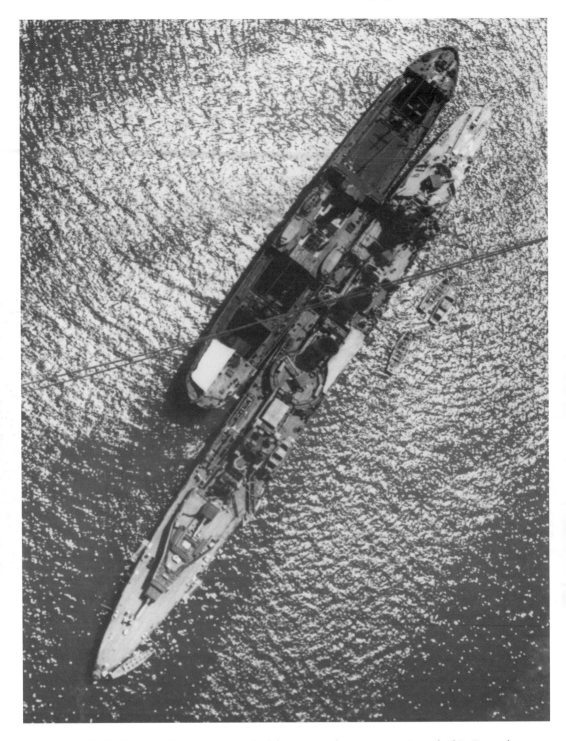

Above: HMS *Caradoc* (D60), photographed from a seaplane in 1919. Launched in December 1916, *Caradoc* was a C-class light cruiser, part of the Caledon group of cruisers. In the inter-war years she served in the Far East.

1919: A POSTSCRIPT

Above: Battlefield tourists, known as 'peace visitors', survey the devastation of war amid the ruins of Ypres. Such tours were organised by Thomas Cook, and a number of other tour operators, from 1919. That year the Saint Barnabas Society was founded in order to enable bereaved relatives to visit the official cemeteries and the graves of their loved ones. Group trips, which were cheaper than individual tours, enabled poorer families to make the pilgrimage to France.

'Germany's Flag Day.' A cartoon published in *Punch* on 13 November 1918, just two days after the Armistice. Note that the central character is Hindenburg and not the Kaiser, who had already abdicated by this time.

The war had ended on 11 November 1918 but sporadic actions took place beyond this time. In parts of Eastern Europe the war was definitely not over, and in Russia the continuing Civil War caused havoc throughout the country. British and American troops had become caught up in this, as were Czechs and other Eastern European troops, who had been captured during the war and were now trying to get back home.

Four empires had collapsed during the fighting. The Russian Empire was no more, nor was the Austro-Hungarian Empire. Germany had lost its empire too. In the Middle East, the Turkish Empire had gone. In their place, the Allies divided some of the spoils, while independent countries sprang up in Central Europe. The power shift led to such events as the Greco-Turkish war of 1920–22. Britain and France had nearly been bankrupted by the cost of the war, while the United States was thrust into a new role on the world stage. Japan had seen the decline of Germany's empire in the east, as well as the downfall of Russia and aimed to capitalise on these events.

Poland wanted land east of the River Bug, containing a large population of Poles, that had formerly been Russian. They went to war with the Bolsheviks, in 1920 and won. The Russians admitted defeat temporarily, but in reality wanted to recover all the lands lost as a result of the peace with Germany at Brest-Litovsk. They also wanted to foment revolution in Europe too and were often the instigators of many internal conflicts between left and right in some of the newly created European countries. Those artificially created countries also had their fair share of ethnic problems too and these would come to the fore on a more frequent basis. The First World War's peace treaties created a series of small, weak countries with internal problems of race or religion that could not easily be contained. It left many of these states suspicious of their neighbours, creating a form of nationalism exploited by those of the far right, None of this was conducive to stability or peace. In Italy, the March to Rome took place in 1922 and Benito Mussolini became the first fascist leader in Europe. In November 1923, a similar event took place in Germany in Munich. The leader of this failed coup was interned – his name Adolf Hitler! Britain and France tried to undo the effects of the Russian Revolution and in the Russian Civil War fought alongside White Russians in their unsuccessful fight against the Bolsheviks.

The peace treaty itself was not easy to achieve. The British, French and Italians wanted major reparations from the Germans, while Woodrow Wilson wanted a more reasonable settlement that would see all the combatants give up their foreign colonies and create a new world order. Ultimately, the British and French got the draconian reparations they sought, while they managed to divide Germany's colonies between themselves. One of Wilson's ideas that did come to fruition was the League of Nations, although the USA did not join and it had no real power to change things. While the war had settled scores and settled some of the problems that brought it about, the post-war peace settlement sowed the seeds of an even greater war, in which some 45 million would die in a conflict that involved the same main protagonists, even if a couple had changed sides. In some respects,

it had created the setting for the next, rather larger conflict. So, was it worth so many deaths to set up the players for the Second, rather more deadly, World War? In hindsight, no! It brought the world a mechanical form of killing, where leaders considered their troops to be mere pawns, ready to die in ever increasing numbers and in ever more terrible ways. It was a war of attrition, one where 'last man standing' was the key to winning. It was, too, a war that showed us just how futile war is. 8 million died, for what? For nothing more than to have their sons and daughters die in the next, more terrible conflict, one in which the civilian was as legitimate a target as the soldier. It was the beginning of total war!

If I should die, think only this of me:
That there's some corner of a foreign field
That is forever England. There shall be
In that rich earth a richer dust concealed;
A dust whom England bore, shaped, made aware,
Gave, once, her flowers to love, her ways to roam,
A body of England's, breathing English air,
Washed by the rivers, blest by suns of home.
And think, this heart, all evil shed away,
A pulse in the Eternal mind, no less
Gives somewhere back the thoughts by England given,
Her sights and sounds; dreams happy as her day;
And laughter, learnt of friends; and gentleness,
In hearts at peace, under an English heaven.

Rupert Brooke's poem could be used by every nation in the conflict with the simple expediency of changing the country to their own. For many millions, their eternal resting place is a foreign field, and for a large percentage, they have no grave. That is the saddest element of the war. It was no more than a futile waste of lives.

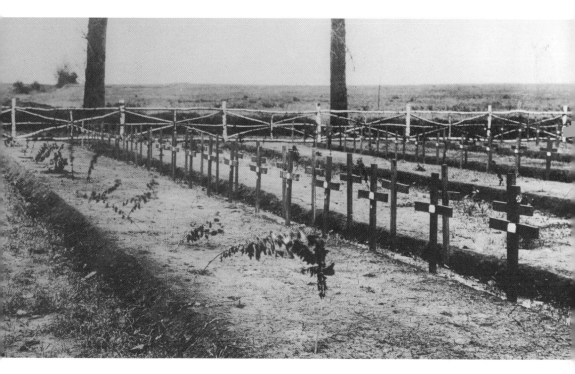

Above: War graves in Flanders. The Imperial War Graves Commission for British Dead in France was constituted in 1917. See page 154.

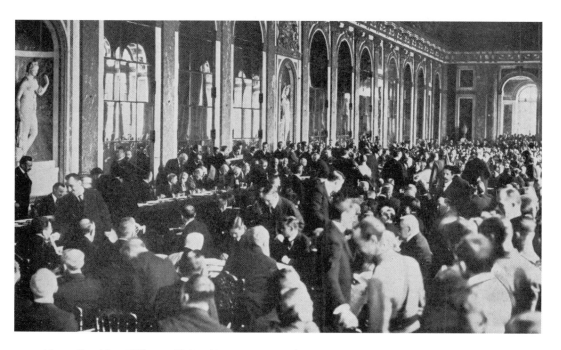

Above: President Wilson affixing his signature to the Peace Treaty in the Palace of Versailles.

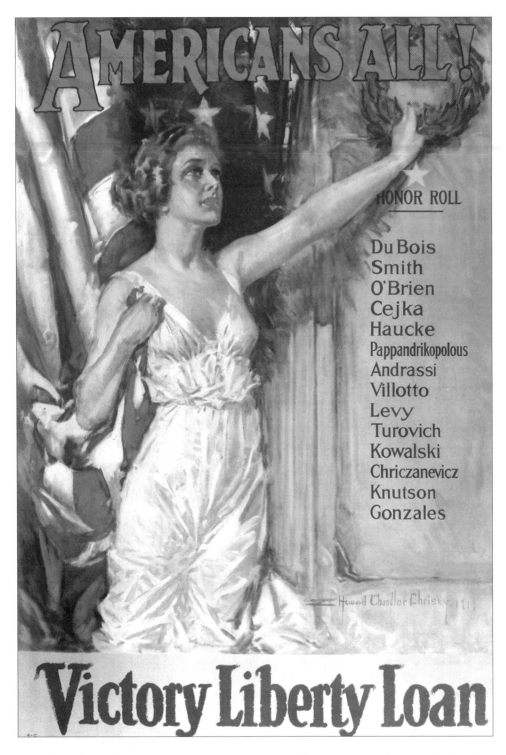

Above: American poster for the Victory Liberty Loan, featuring a comely young lady in her undergarments!

Left: A Canadian Victory Loan poster from 1919, featuring the Prince of Wales (briefly to become Edward VIII until his abdication in 1936). The young prince was undoubtedly the glamorous face of the British royal family. He joined the Grenadier Guards in 1914 and although willing to serve at the front Kitchener, the Secretary of State of War, wouldn't allow it. Despite this, Edward visited the front as often as possible and became a popular figure with the serving men.

"I hope every City and District will win my flag"
H.R.H. Prince of Wales

Let us win the
PRINCE OF WALES' FLAG
VICTORY LOAN 1919

WORLD PEACE WITH LIBERTY AND PROSPERITY

1919

HAPPY·NEW·YEAR

Right: A chirpy and patriotic American poster calling for world peace with liberty and prosperity in 1919. Although the Americans had only been active participants in the fighting for the last year of the war they had, nonetheless, lost almost 117,000 men in combat and an estimated 757 civilians had also died, many at sea including the 128 US victims of the sinking of the RMS *Lusitania* in 1915.

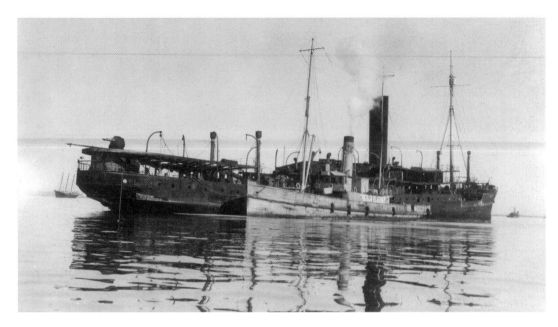

Above: The USS *Ophir*, of 8,905 grt, was a Dutch ocean liner seized by the US Government in March 1918, while at Pearl Harbor. She was swiftly turned into a troopship. On her third voyage to Marseilles, she caught fire and, after three days alight, sank in Gibraltar on 11 November 1918. She was salvaged in January 1919 and, with basic repairs, entered service again in November 1919. She is shown here afloat again in January 1919 with the salvage tug *Crocodile* at her side.

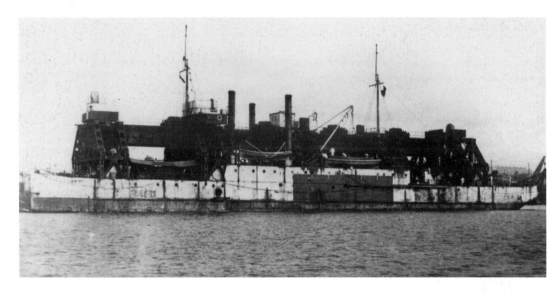

Above: HMS *Cyclops* was a Royal Navy repair ship that served at Scapa Flow for the duration of the war. Paid off in April 1919, she was later converted to a submarine depot ship.

Opposite page: Back to Blighty! Crowds flock to London's Charing Cross railway station on 25 February 1919 to welcome home the Guards, 2nd Grenadiers.

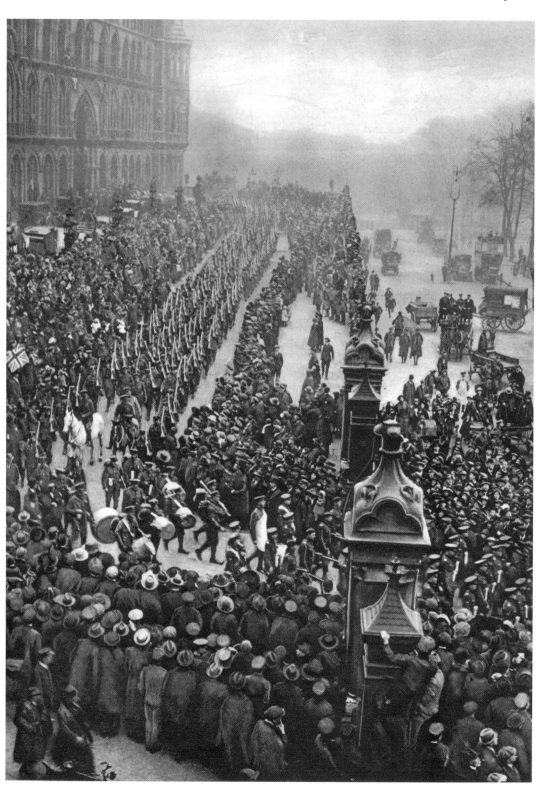

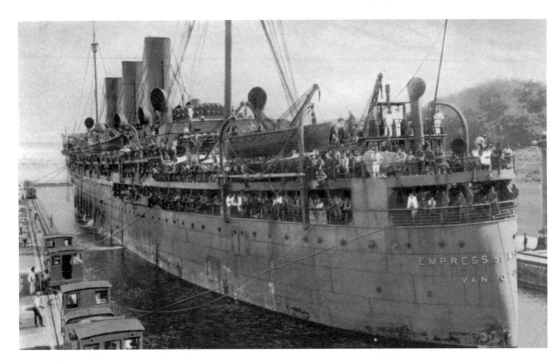

Above: The end of the war saw a huge effort to return troops back to their homelands. The Canadian Pacific liner RMS *Empress of Australia* is shown here in the Panama Canal, trooping back to Australia with ANZAC troops aboard. She is still in her all-grey wartime livery but all evidence of her guns has been removed.

Above: The Orient Liner *Orotava* with troops homeward bound for Australia at the quayside, waiting to board.

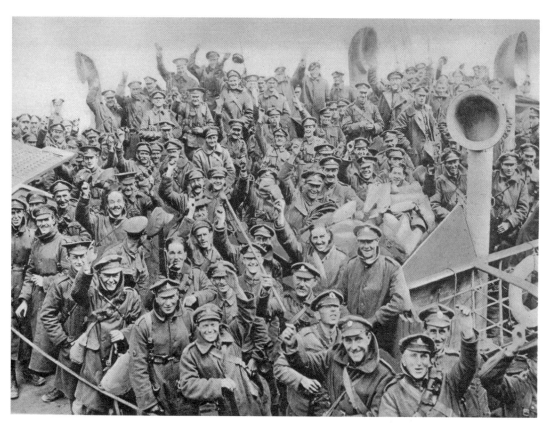

Top: Home at last! It's all smiles as these RFA gunners arrive at Dover from Salonika. *Bottom:* Landing at Dover after four and a half years' war service abroad.

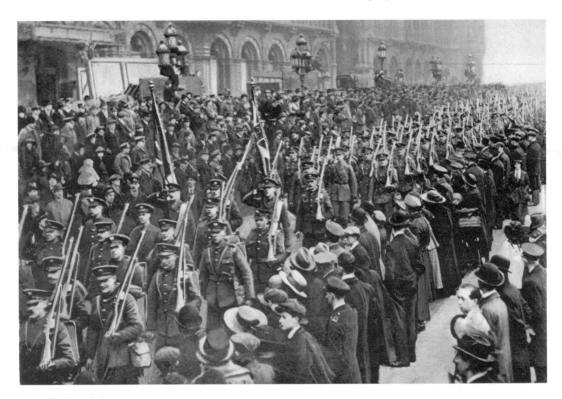

Familiar scenes of homecoming in 1919. *Above:* Back from the war, a public welcome for the Guards arriving at St Pancras station. *Opposite page:* April 1919 saw the repatriation of the Danes of Schleswig who had been forced to fight by the Germans and who were then taken prisoner by the Allies.

Demobilisation of the British Army

In the lead up to the Armistice the War Office had been making preparations for the demobilisation of all British and Colonial forces. One of the key factors was that industry should be ready to absorb the labour released, and to smooth the process it was spread over three phases from November 1918 to January 1919, then from January to February, and finally from February onwards. Most conscripts and volunteers were home by the end of 1919, although those men serving in the regular army had to complete their full term of service. Those with scarce industrial skills were released early, and men who had joined up in the early stages of the war were also given priority. Before returning to Blighty each man was given a medical examination and was issued a Plain Clothes form and a Certificate of Employment showing the type of work he had undertaken in the war. A Dispersal Certificate recorded personal details and equipment. (Losses would be deducted from his wages.) Each man would be billeted at a Dispersal Camp on the Continent before arrival at a Dispersal Centre in England. The Out of Work Donation Policy insured against up to twenty-six weeks of unemployment in the first twelve months.

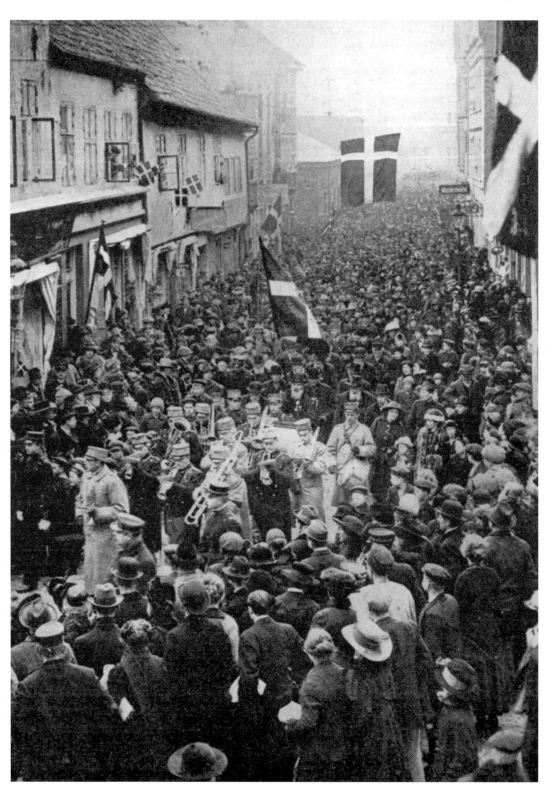

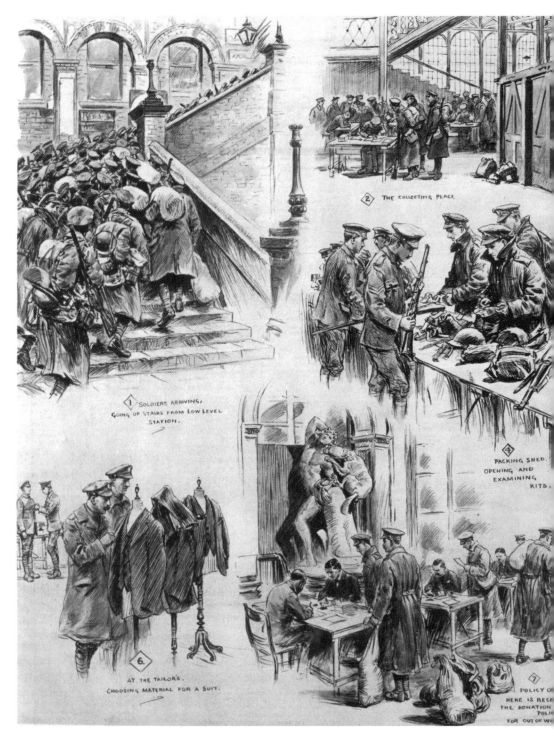

The collecting place

① SOLDIERS ARRIVING,
GOING UP STAIRS FROM LOW LEVEL
STATION.

② THE COLLECTING PLACE

④ PACKING SHED.
OPENING AND
EXAMINING
KITS.

⑥.
AT THE TAILOR'S,
CHOOSING MATERIAL FOR A SUIT.

POLICY OF
HERE IS RECE
THE DONATION
POLIC
FOR OUT OF WO

A 1919 spread from *The Illustrated London News* showing the scenes during the demobilisation of around 4,000 men per day at the Crystal Palace. 1. Arrival. 2. The collecting place. 3. Sorting shed where the men are divided into armed and unarmed parties. 4. Packing shed where kit

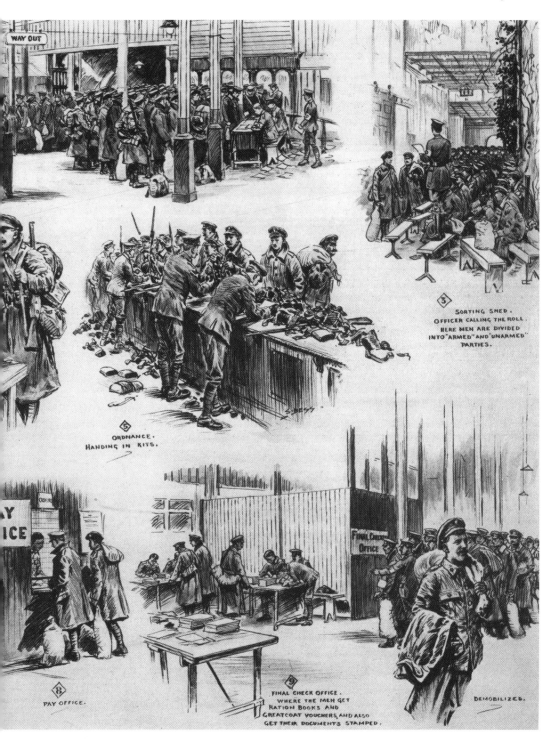

is examined. 5. Ordnance, handing in. 6. At the tailors, choosing material for a suit. 7. Policy office. 'Here is received the donation policy for out of work.' 8. Pay office. 9. Final check office, where the men get ration books, great coat vouchers and documents stamped. Demobilised!

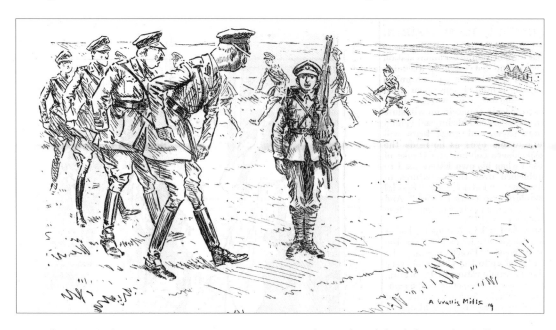

Above: 'Battalion Inspection in France – Men are being demobilised faster than officers.' A *Punch* cartoon published in April 1919.

'Technicalities of Demobilisation. Officer: What are these men's trades or callings, Sergeant? Sergeant: Slosher, slabber and Wuzzer, Sir.' *Punch*, February 1919.

'Welcome Home Boys.' This patriotic sheet music was published in Pittsburgh, USA, in 1919. The Spirit of Peace is shown presenting garlands of peace to a sailor and a soldier.

The Zeeland Steamship Company's steamer „Oranje-Nassau"
at Tilbury with exchanged wounded soldiers.

VLISSINGEN ORANJE-NASSAU VLISSINGEN

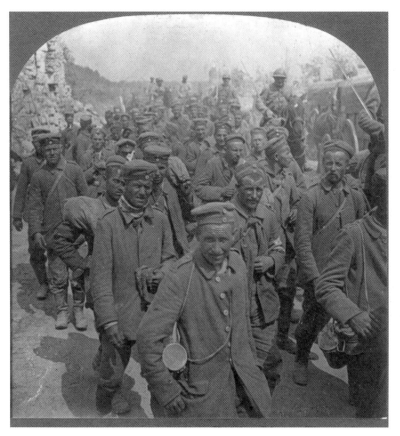

Above: One thing not realised about the war was that the Red Cross arranged for numerous prisoner transfers of severely injured military personnel. This view shows the SS *Orange Nassau* with British soldiers being returned back to the UK in exchange for injured Germans. Many men of all nationalities were also kept in camps in Switzerland.

Left: German prisoners filing into France.

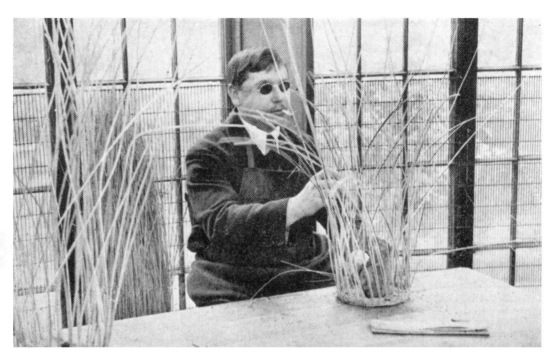

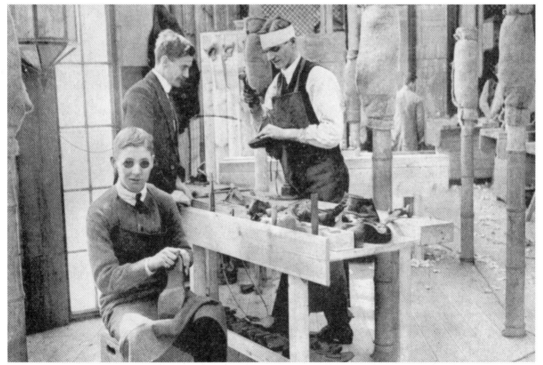

Soldiers and sailors blinded in the war were taught 'useful occupations in order to reduce their dependance on others'. These images show the St Dunstan's Hostel, established by Sir Arthur Pearson near Regent's Park, where the 'afflicted' learnt basket weaving and boot repairing.

Caring for the wounded. *Top:* Pembroke Lodge in Kensington, the residence of Bonar Law, the politician and a future prime minister, was loaned as a hospital for wounded officers. *Below:* A similar scene in the courtyard of Fulham Palace, lent by the Bishop of London.

The treatment of the returning wounded was the responsibility of the Royal Army Medical Corps. Many of the lesser injuries could be treated by coventional means, but new equipment and methods were needed for the more severely wounded.

Right: Amputations were legion and here a young man is being fitted with articifical arms. Some degree of control was possible by movements of the muscles of the back, chest and shoulders. In the middle image the new arms are shown gripping a fountain pen, glass and a fork.

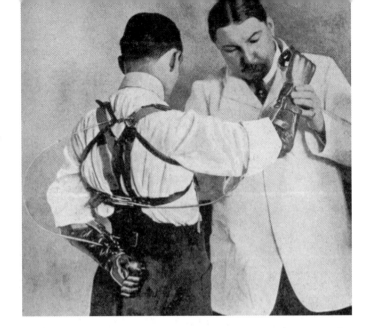

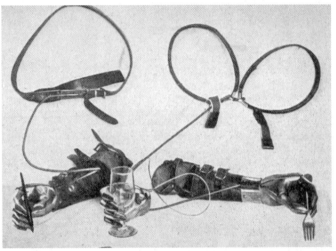

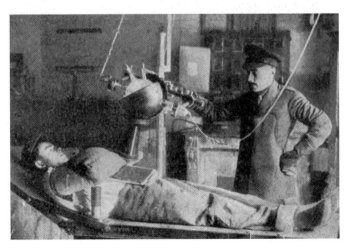

Bottom right: An X-ray machine is used to locate a bullet lodged in the arm of a French soldier in a Canadian hospital in France.

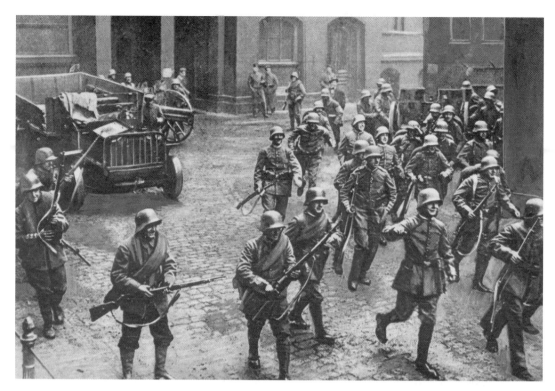

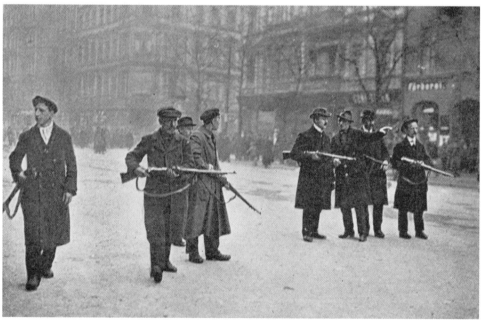

Insurrection in Germany. *Top:* Government troops hurry to encounter the Spartacists on the streets of Berlin. The Sparticists' uprising of 4–15 January was a general strike accompanied by armed encounters between the opposing parties and its supression marked the ending of the revolution. *Bottom:* Armed Sparticists holding a street in Berlin.

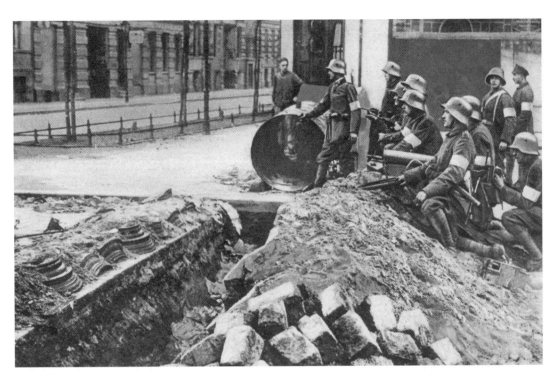

Top: Government troops who have seized a Spartacist trench and barricade in the Frankfurter Allee, Berlin. *Bottom:* On the look-out for Spartacists in one of Berlin's main thoroughfares.

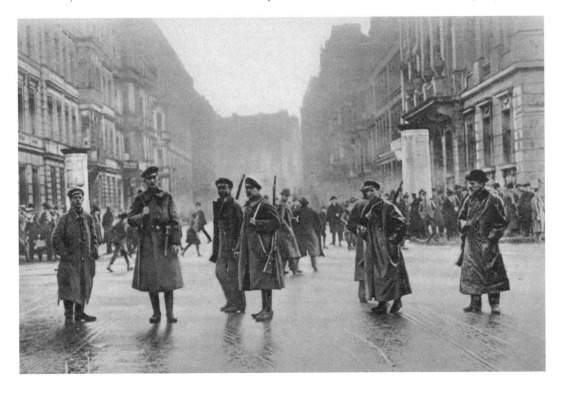

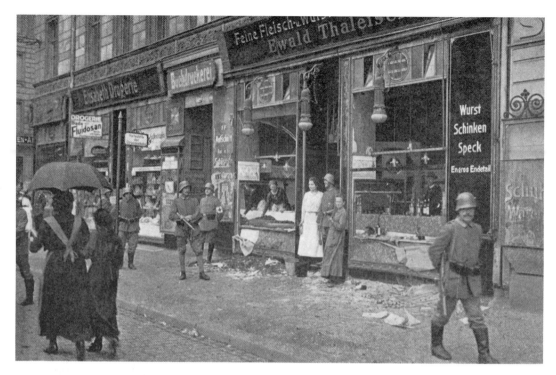

Top: The result of food riots in Berlin. This shop, a delicatessen in the Invalidenstrasse, has been wrecked by looters. *Below:* Federal elections were held in Germany in January 1919 and this public demonstration against Bolshevism has been organised by supporters of the Combined Democratic Parties. On 11 February 1919 the National Assembly elected Friedrich Ebert as the first president of the Weimar Republic.

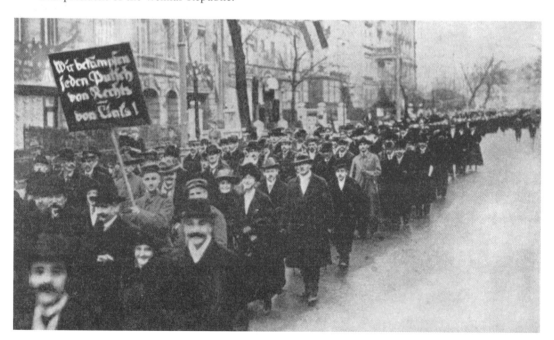

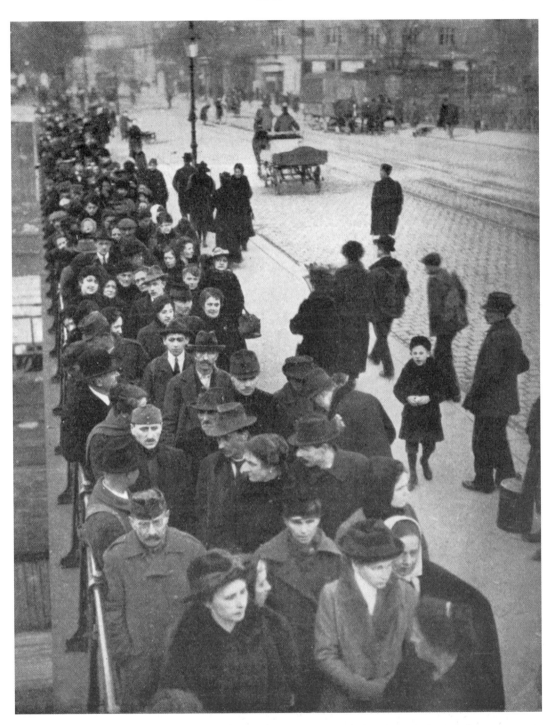

Above: The harsh winter of 1919/20 left people in Austria short of both fuel and food. This is a queue outside the American Food Commission's offices in Vienna. For firewood to keep warm and cook, people would go to the Wiener Wald, an ex-emperor's ancient forest on the outskirts of Vienna, to gather whatever wood they could find.

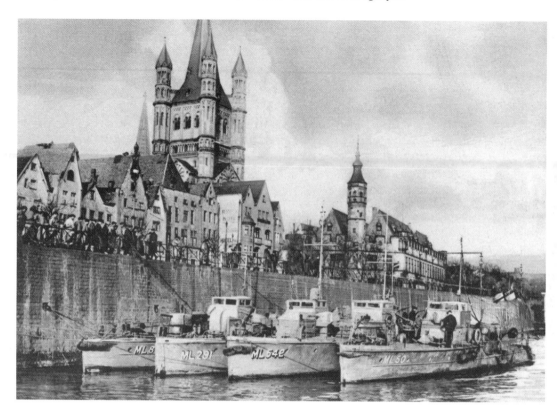

The British Army occupied the Rhineland upon the ending of the war. Making Cologne their base, a fleet of motor launches was brought up the river and they are shown above in Cologne in mid-1919. *Below:* Two British soldiers are keeping a close watch on the barges plying the Rhine during the blockade of Germany.

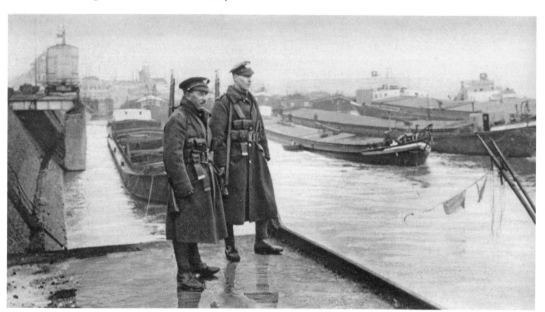

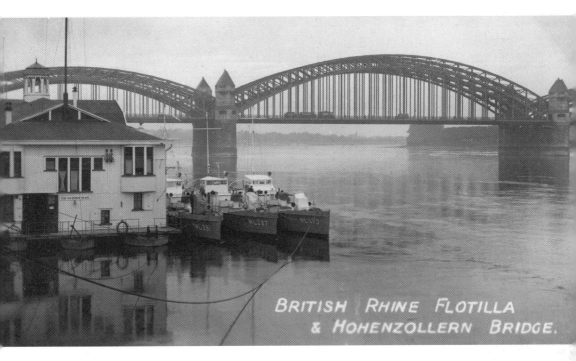

BRITISH RHINE FLOTILLA & HOHENZOLLERN BRIDGE.

Above: British motor launches moored near the Hohenzollern Bridge. *Below:* Three of the launches, headed by ML54, on patrol on the Rhine after passing under the bridge at Cologne.

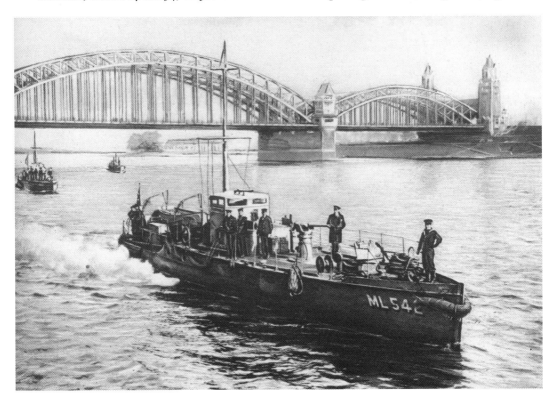

Two images of the scene at Cologne during the winter of 1918/19. *Above:* Ice skating on the banks of the Rhine when the city was the headquarters of the British Army of Occupation. *Below:* Soldiers watching ice floating down the Rhine. For many German citizens the harsh winter added to the misery of food and fuel shortages as a result of the blockade.

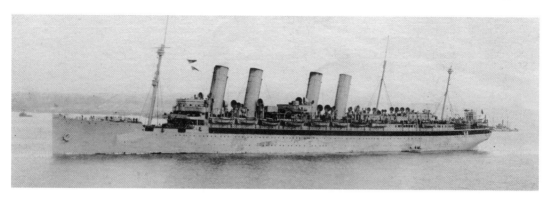

Top: On 26 January 1919, the merchant ship that first gave the Germans the Blue Riband, the *Kaiser Wilhelm der Grosse*, entered Brest harbour on a voyage to return American troops back to the USA. She was renamed USS *Agamemnon* when commandeered by the US Navy.

Middle: HMS *Lados* and USS *Yankton* at Murmansk, Russia, in May 1919. The British and Americans tried to help the White Russians against the Communists but ultimately failed.

Bottom: On 21 June 1919, a party of schoolchildren from Kirkwall went on a Sunday School trip to see the German High Seas Fleet at Scapa Flow. The children, aboard the tender *Flying Kestrel*, had a grandstand view of the ships being scuttled. Here, they return to Kirkwall.

Above: The Supreme War Council of the Allies meets at Versailles in October 1918 to discuss the terms to be offered to the Germans. Clemenceau, Lloyd George and Bonar Law can be seen seated at the centre of the table. *Below:* Opening meeting of the Peace Conference in Paris, 18 January 1919. An official interpreter stands to read M. Ponicaré's address in English.

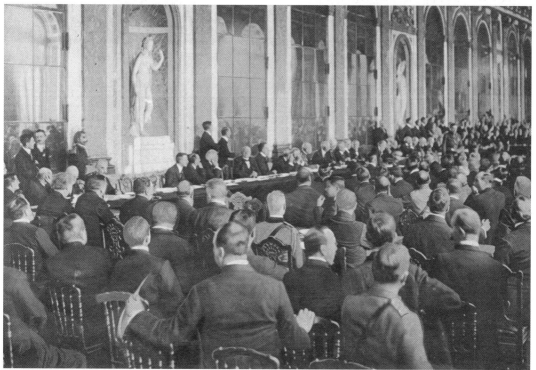

Top: German delegates for receiving the Peace Treaty at their table in the Trianon Palace, Versailles. *Bottom:* In the crowded Hall of Mirrors at Versailles, delegates await the moment of the signing of peace on 28 June 1919. At ten minutes to four a crash of gunfire announced to the crowds waiting outside that the war was officially ended. Faced with harsh terms, the Germans had put off signing until threatened by the Allies with military occupation.

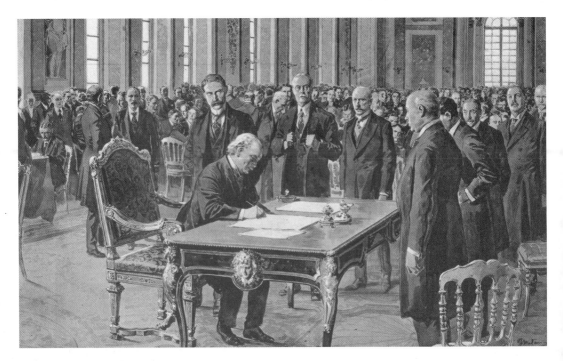

Above: The Prime Minister, Lloyd George, signs the Peace Treaty in the Hall of Mirrors at Versailles while the other members of the British delegation await their turn to sign the document. *Below:* The scene at the Royal Exchange, London, with the reading of the royal proclamation announcing the signing of the Peace Treaty.

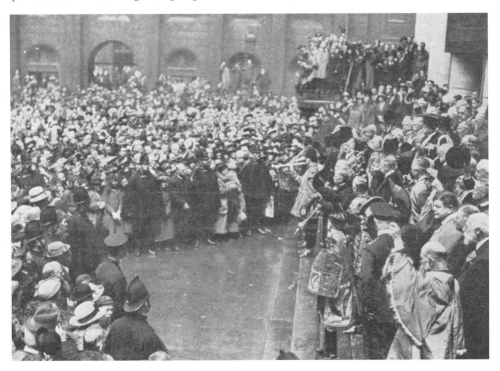

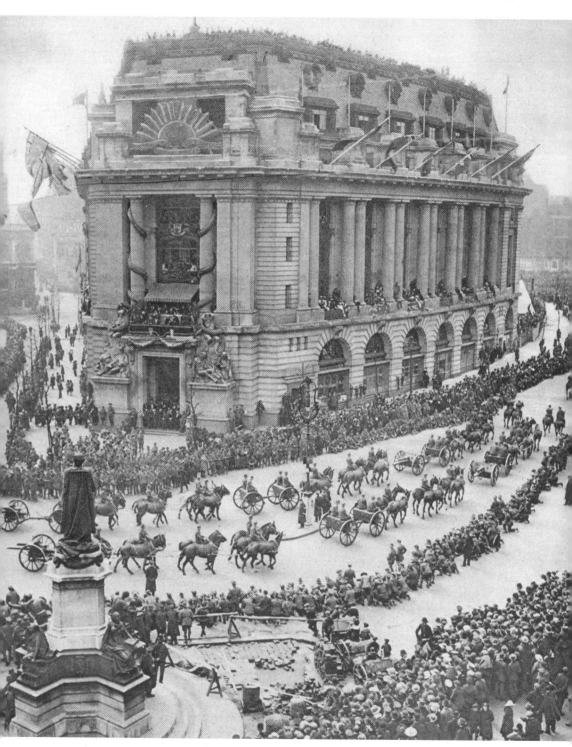

Triumphal march of Dominion troops through London on 3 May 1919, showing artillery passing Australia House in The Strand.

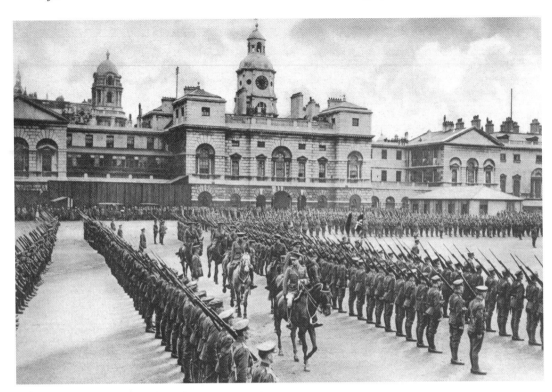

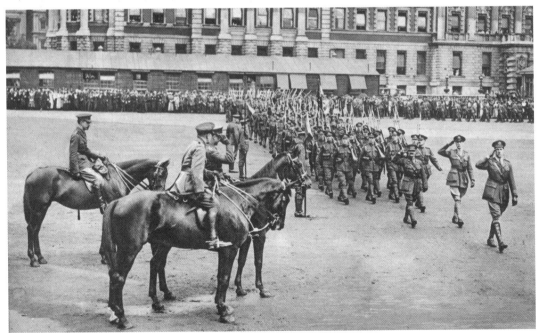

The Prince of Wales welcomes home members of the Royal Naval Division. He is shown inspecting the men at Horse Guards Parade, top, and taking the salute outside the Admiralty, bottom, on 6 June 1919.

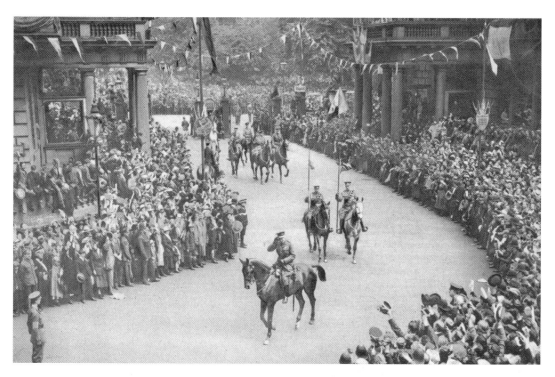

Above; Field-Marshal Sir Douglas Haig riding in the Victory March of Allied troops through London on 19 July 1919. *Below:* Men of the Tank Corps pass along The Mall. These Medium Mk C 'Hornet' tanks entered service too late to see action during the war.

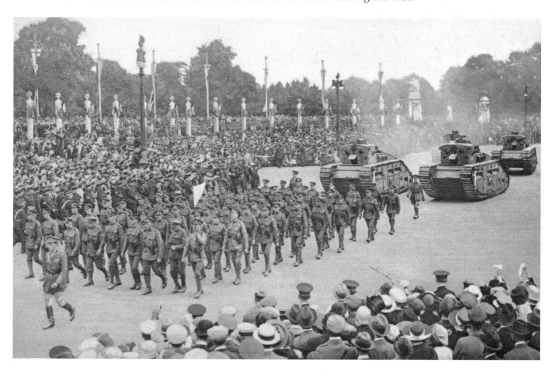

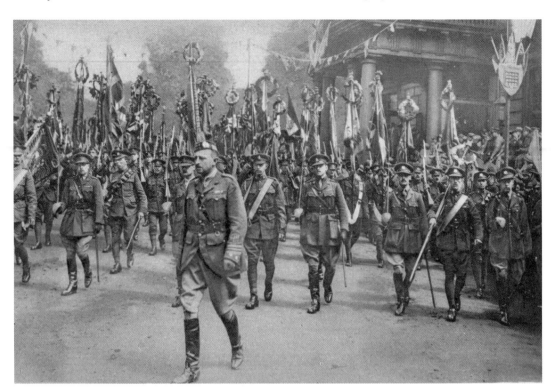

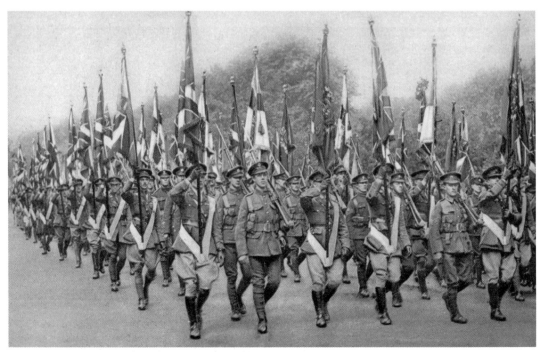

This page: Procession of British standards and colours borne in the Peace March held in London on 19 July 1919. Similar peace parades and parties were held throughout the country.

Similar parades were also held by the French in 1919, with the Victory March in Paris taking place on Bastille Day, 14 July.

Above: Field-Marshal Sir Douglas Haig leading the British Empire troops through Paris. Haig had been created Earl Haig in 1919 and his military career ended the following year. He died in 1928. In the ensuing decades history has not looked kindly on Haig's leadership of the BEF during the First World War, which saw casualty figures of over 2 million casualties, with some sources labelling him 'Butcher Haig'.

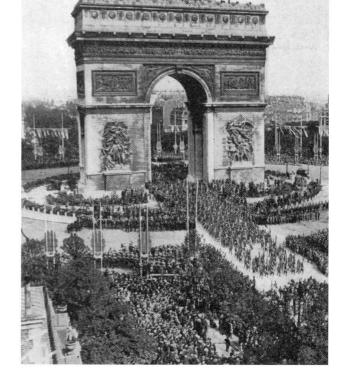

Right: The Victory March procession passing through the Arc de Triomphe.

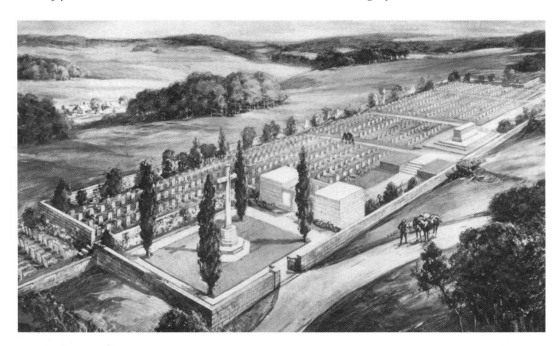

Above: A war cemetery as designed by the Imperial War Graves Commission for British Dead in France. This was constituted in 1917 and followed on from the work of recording graves sites by various organisations including the Red Cross. Official policy dictated that the bodies of the fallen should not be repatriated and consequently land was obtained from the French government for their burial. *Below:* The Tyne Cot Cemetery in the Ypres Salient. The graves of unidentified soldiers are inscribed, 'British Soldier, Known Unto God.' On the panels on the curved wall are the names of over 34,000 men who fell at Ypres but were denied a proper burial.

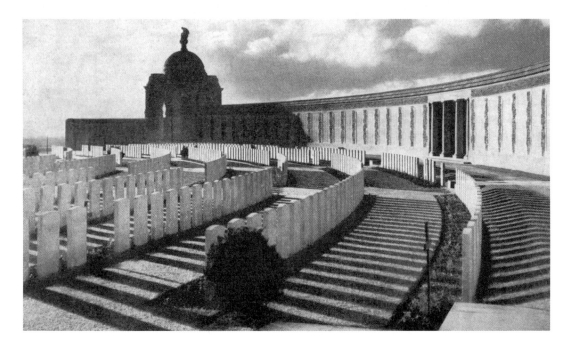

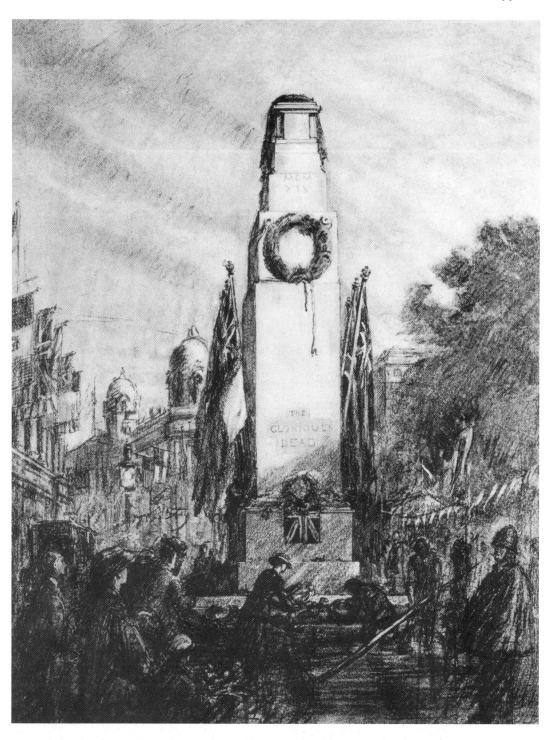

The Cenotaph, meaning an 'empty tomb', in Whitehall, London, was designed by Edwin Lutyens and is built of Portland stone. It was unveiled on 11 November 1920 and replaced an earlier wood-and-plaster cenotaph on the site. This illustration was published in 1919.

Above: HMS *Verdun* brought the remains of an unidentified British soldier back to Dover, to be interred in Westminster Abbey. Shown here are the chaplains that accompanied the body.

The Tomb of the Unknown Soldier

On 11 November 1920 the remains of an unknown British soldier were buried at Westminster Abbey, 'amongst the kings', simultaneously with the internment of a similar French soldier at the Arc de Triomphe, Paris. The idea had its origins in 1916 when army chaplain Reverend David Railton had come across a rough cross inscribed, 'An Unknown British Soldier'. Railton wrote to the Dean of Westminster and the idea was strongly supported by the the prime minister, David Lloyd George. In early November 1920 suitable remains from various battlefields were brought to the chapel at Saint-Pol-sur-Ternoise near Arras, and one was selected. The body was placed in a plain coffin, later replaced by one built from the oaks at hampton Court Palace. A medieval crusader's sword – selected by the King from the Royal Collection – was affixed to the top with an iron shield bearing the inscription, 'A British Warrior who fell in the Great War 1914–1918 for King and Country'. It was taken by train to Boulogne and, in the presence of Marshal Foch, taken up the gangway onto HMS *Verdun* for the journey to Dover under the escort of six battleships. Having arrived at Victoria station in London, the following morning it was taken by gun carriage to Westminster Abbey and in the presence of the Royal Family and more than 100 women, chosen because they had lost their sons or husbands in the war, it was interred in the West Nave.

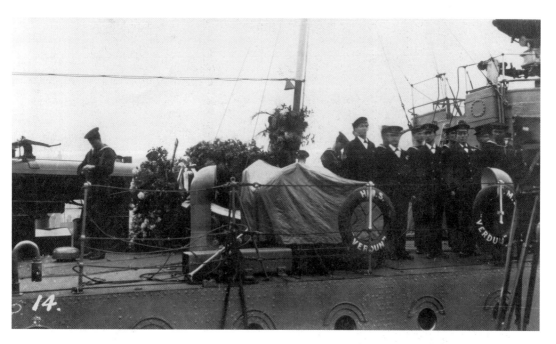

Above: Surrounded by a naval guard of honour, the Unknown Soldier is ready to be disembarked from HMS *Verdun* at Dover for his final journey to Westminster Abbey. *Below:* The procession proceeds through the docks at Dover, 10 November 1920.

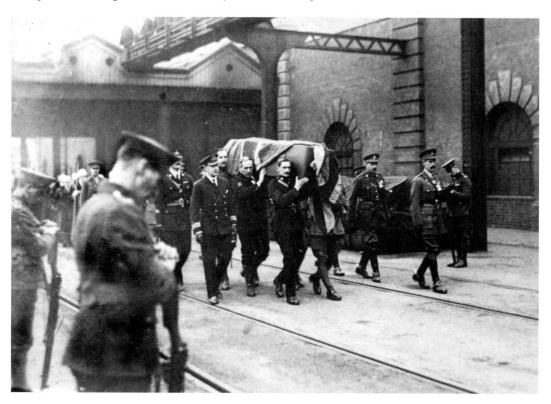

THE 1919 MODEL.

'Mr Punch: 'They've given you a fine new machine, Mr Premier, and you've got plenty of spirit; but look out for the bumps.' In this cartoon featuring Lloyd George and published on New Year's Day, 1919, the aeroplane is a symbol of modernity and the new post-war era.

The Dawn of a New Age

The First World War resulted in a unprecedented period of accelerated development in technological progress in all manner of directions, but the one area that has come to epitomise this dawn of modernity is aviation. When the war had commenced in August 1914 it was barely eleven years after the Wright brothers had made their first tentative powered hops at Kittyhawk in December 1903, and only five since Louis Blériot had flown his Type XI monoplane across the Channel in July 1909. By 1914 the embryonic air forces were equipped with a ragbag of craft, most of which were either civilian aircraft, or directly developed from them, and built of wood and canvas, and their initial role was in aerial recconnaissance. This was also the case for the rigid-framed airships developed in Germany, principally by Ferdinand von Zeppelin. But progress was rapid and the aircraft became more powerful and more manoeuvrable, transforming into efficient combat and bombing machines. In June 1919, John Alock and Arthur Whitten Brown made the first non-stop transatlantic flight, going from Newfoundland to a bog in Ireland. In terms of international air travel the airships took the lead when, in July 1919, the British R34 – built by Beardmores and incorporating many design ideas gathered from the L33 Zeppelin which had been brought down in 1917 – made the first non-stop, and two-way, crossing of the Atlantic. Scheduled transatlantic airship services commenced in the late 1920s. (Charles Lindbergh's solo crossing came seven years later, in 1926, by which time ninety-one people had already hopped across the 'Pond'.) The decades immediately after the First World War saw a golden age of air travel.

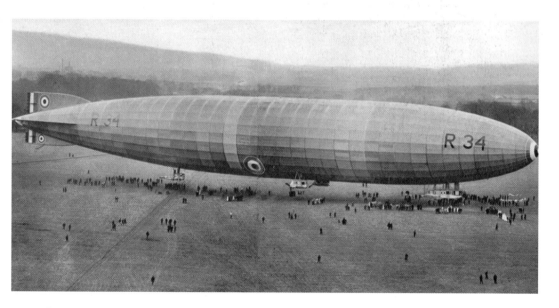

Above: The British-built R34, which made the first two-way transatlantic crossing in July 1919. The rapid development of both airships and heavier-than-air aircraft during the war heralded a new era in international air travel.